Praise for *The Dangerous Book for Boys*

"Offers a portal back to a time of 'Sunday afternoons and long summer days' . . . suggests activities with a whiff of rebelliousness without advocating anything truly unsafe. . . . Refreshingly free of brands or logos."

—Newsweek

"A delightful collection of old-fashioned mischief."

—New York Post

"It's no use trying to shield your offspring from the disastrous influence of popular culture. . . . Better to set that influence next to something it has no hope of competing with: the excitement and pride of knowing semaphore or ciphers or Robert Scott or bugs or fossils."

—New York Sun

"A sepia-toned celebration of the lost arts of childhood, complete with information on how to make a tree house, fold paper airplanes, and skip stones."

—New York Times

"A zestfully nostalgic celebration of boyhood past . . . [the book] has many of the timeless qualities of an ideal young man: curiosity, bravery, and respectfulness; just enough rogue to leaven the stoic. . . . Rudyard Kipling would have loved it." *—Time*

"A testosterone-fueled throwback of a field guide."
 —Vanity Fair

THE POCKET DANGEROUS BOOK FOR BOYS:

THINGS TO KNOW

Many of the pieces in this edition have been selected from the much-loved *The Dangerous Book for Boys*. They are a collection of useful trivia and information; things that every boy should know.

This edition is a perfect pocket format for readers to take everywhere with them. It has new drawings and new chapters full of fascinating facts.

Also by Conn and Hal Iggulden:

The Dangerous Book for Boys
The Dangerous Book for Boys Yearbook
The Pocket Dangerous Book for Boys: Things to Do

Also by Conn Iggulden:

The Emperor series
The Gates of Rome
The Death of Kings
The Field of Swords
The Gods of War

The Conqueror series
Wolf of the Plains
Lords of the Bow

Blackwater

The Pocket
DANGEROUS
Book
for
Boys

THINGS TO KNOW

Conn Iggulden & Hal Iggulden

COLLINS

An Imprint of HarperCollins *Publishers*

An edition was published in the U.K. by HarperCollins Publishers in 2008

HarperCollins books may be purchased for educational, business, or sales promotional use. For information, please write: Special Markets Department, HarperCollins Publishers, 10 East 53rd Street, New York, NY 10022.

FIRST U.S. EDITION

Library of Congress Cataloging-in-Publication Data has been applied for.

ISBN 978-0-06-164993-6

08 09 10 11 12 WBC/QW 10 9 8 7 6 5 4 3 2 1

To all of those people who said "You have to include . . ." until we had to avoid telling anyone else about the book for fear of the extra chapters. Particular thanks to Bernard Cornwell, whose advice helped us through a difficult time, and Paul D'Urso, a good father and a good friend.

CONTENTS

—————✦—————

INTRODUCTION

The problem with a love of knowledge is that it leaps on new subjects like an excited terrier. This portly little book has new material in it, of course. Of *course* people want to know the words to national anthems! The Twelve Tables of Roman Law? Who *wouldn't* want such a thing easily to hand? Sometimes, it's quite difficult to simply stop.

Neither of us expected the original book to do well—and more than one publisher agreed wholeheartedly with us. What happened after that was simply wonderful. We discovered that there are large numbers of people who care about exactly the same things, who are interested in everything, from stories of courage, to British history, to, well, girls and things. From the very old to the very young, the book reached out to fathers and sons. That matters, in this sometimes difficult world. It really does.

It makes sense then to dedicate this pocket book to all those who recommended the original to friends and family. To those who said "try this" to a son, nephew, and grandson and then took the time to make things and learn things with them. Well done, lads.

Conn and Hal Iggulden

ANTHEMS

———✦———

A T ANY BALLGAME or large gathering it can be really annoying when the crowd starts to sing and you can't join in because you don't know the words. To save you from this embarrassment, here are some of the most important national and popular songs in North America. If you take the time to learn them, they will give you immense pleasure in the years to come.

THE STAR-SPANGLED BANNER

The words to the national anthem of the United States were written in 1814 by Francis Scott Key. The War of 1812 saw the British burn the White House and the Capitol in Washington, D.C. On the night of September 12, 1814, Key watched the British attack Fort McHenry in the port of Baltimore, Maryland. Late at night on the 13th, the British suddenly stopped shelling the port, and as the sun began to rise Key was able to see clearly the huge flag of the United States, still proudly flying. The fort had survived the attack, and Key composed this poem, which described Key's pride and relief that the symbol of the United States had withstood the attack. The music to Key's poem may have been written by an English composer, Thomas Arne, who incidentally also composed the tune to "Rule

Brittania." An act of Congress in 1931 officially designated "The Star-Spangled Banner" as the national anthem of the United States.

Oh, say, can you see by the dawn's early light,
What so proudly we hailed at the twilight's last
gleaming?
Whose broad stripes and bright stars, thro' the
perilous fight;
O'er the ramparts we watched, were so gallantly
streaming.
And the rocket's red glare, the bombs bursting in air,
Gave proof through the night that our flag was still
there.
Oh, say, does that star-spangled banner yet wave
O'er the land of the free and the home of the brave?

O CANADA

The national anthem of Canada was composed in 1880 by Calixca Lavallée; the French lyrics were penned by Sir Adolphe-Basile Routhier. In 1908 Robert S. Weir translated the French words, but not until 1980 did the song officially become Canada's national anthem.

O Canada!
Our home and native land!
True patriot love in all thy sons command.

With glowing hearts we see thee rise,
The True North strong and free!

From far and wide,
O Canada, we stand on guard for thee.

God keep our land glorious and free!
O Canada, we stand on guard for thee.
O Canada, we stand on guard for thee.

AMERICA (MY COUNTRY 'TIS OF THEE)

Samuel F. Smith wrote the words to this patriotic song in 1831 while studying theology at Andover Theological Seminary in Massachusetts. He and the famous organist Lowell Mason set the words to an existing tune, known variously as a national hymn of England, Germany, Denmark, and other countries. The first public performance of the anthem took place on July 4, 1831, in Boston.

My country, 'tis of thee,
Sweet land of liberty,
Of thee I sing;
Land where my fathers died,
Land of the pilgrims' pride,
From every mountainside
Let freedom ring!

My native country, thee,
Land of the noble free,

Thy name I love;
I love thy rocks and rills,
Thy woods and templed hills;
My heart with rapture thrills,
Like that above.

Let music swell the breeze,
And ring from all the trees
Sweet freedom's song;
Let mortal tongues awake;
Let all that breathe partake;
Let rocks their silence break,
The sound prolong.

Our father's God to Thee,
Author of liberty,
To Thee we sing.
Long may our land be bright,
With freedom's holy light,
Protect us by Thy might,
Great God our King.

AMERICA, THE BEAUTIFUL

In 1893 Katherine Lee Bates, a poet and professor, wrote these words to express her joy and wonder at the view from Pike's Peak in Colorado. The poem first appeared in a weekly journal, *The Congregationalist*, in 1895. Bates

revised the words in 1904 and again in 1913. Legend has it that the poem was sung to almost any tune that would fit the words. The music we know today was written in 1882 by Samuel Ward, long before the poem itself was composed. The music and words were matched in 1910. Many Americans believe this song should be our national anthem.

O beautiful for spacious skies,
For amber waves of grain,
For purple mountain majesties
Above the fruited plain!
America! America! God shed His grace on thee,
And crown thy good with brotherhood
From sea to shining sea!

O beautiful for pilgrim feet,
Whose stern impassion'd stress
A thoroughfare for freedom beat
Across the wilderness!
America! America! God mend thine ev'ry flaw,
Confirm thy soul in self-control,
Thy liberty in law!

O beautiful for heroes proved
In liberating strife,
Who more than self their country loved,
And mercy more than life!
America! America! May God thy gold refine

Till all success be nobleness,
And ev'ry gain divine!

O beautiful for patriot dream
That sees beyond the years
Thine alabaster cities gleam,
Undimmed by human tears!
America! America! God shed His grace on thee,
And crown thy good with brotherhood
From sea to shining sea!

Two other songs that express the American way of life are "This Land Is Your Land," words and music written in 1940 by Woody Guthrie, and "Take Me Out to the Ball Game," written in 1908 by Jack Norworth (music by Albert von Tilzer) and sung during the seventh-inning stretch at every baseball game from major league contests to sandlot pickup games. This song originally had two verses and one chorus; these days everyone just sings the famous chorus.

THIS LAND IS YOUR LAND

This land is your land, this land is my land
From California to the New York Island
From the Redwood Forest to the Gulf Stream waters
This land was made for you and me.

As I went walking that ribbon of highway
I saw above me that endless skyway
I saw below me that golden valley
This land was made for you and me.

I roamed and I rambled and I followed my footsteps
To the sparkling sands of her diamond deserts
While all around me a voice was sounding
Saying this land was made for you and me.

The sun came shining, and I was strolling
And the wheat fields waving and the dust clouds rolling
As the fog was lifting, a voice was chanting,
This land was made for you and me.

This land is your land, this land is my land
From California to the New York Island
From the Redwood Forest to the Gulf Stream waters
This land was made for you and me.

TAKE ME OUT TO THE BALL GAME

Take me out to the ball game,
Take me out with the crowd.
Buy me some peanuts and Cracker Jack,
I don't care if I never get back,
Let me root, root, root for the home team,
If they don't win it's a shame.
For it's one, two, three strikes, you're out,
At the old ball game.

EXTRAORDINARY STORIES— PART ONE

<div align="center">——✼——</div>

STORIES OF COURAGE and determination are sometimes underrated for their ability to inspire. It is true that once-famous names can slip from the memory of generations, names like Charles George Gordon, Richard Francis Burton, Florence Nightingale, Robert Scott, Herbert Kitchener, Henry Morton Stanley, Rudyard Kipling, Isambard Kingdom Brunel, and a host of others. Their lives, their stories, were once known to every schoolboy; held up as examples of fortitude and honor. These values have not ceased to be important in the modern world, nor have the stories become less moving. We have chosen five of our favorites. They range from Robert Scott's death in Antarctica to the astonishing modern story of Aron Ralston's struggle in the mountains of Utah. These are all tales worth knowing.

ROBERT SCOTT AND THE ANTARCTIC

Robert Falcon Scott was born on June 6, 1868. All his life, he was known as "Con," a short form of his middle name. He came from a seafaring family, with uncles, great-uncles, and grandparents all serving in the Royal Navy. His father owned a small brewery in Plymouth that had been bought with prize money from the Napoleonic wars.

"Con" Scott joined HMS *Boadicea* at the age of thirteen as a midshipman. It was a hard world, requiring instant obedience and personal discipline. By twenty-two, he was a lieutenant with first-class certificates in pilotage (steering/navigation), torpedoes, and gunnery, with the highest marks in his year for seamanship.

He had met Sir Clements Markham, the president of the Royal Geographical Society, more than once in the course of his naval duties, impressing the older man with his intelligence and demeanor. When, at the turn of the century, the Royal Society wanted someone to head an expedition to the South Pole, Sir Clements Markham fought to have Scott lead the group.

Scott had no experience with the extremes he would be facing at that point in his career. He solved this problem by consulting those who had, traveling to Oslo to confer with Fridtjof Nansen, a Norwegian explorer of Arctic regions who would later become the Norwegian ambassador to London. They became firm friends and Scott accepted Nansen's advice to get dogs to pull sleds, buying twenty-three dogs in Russia for his first attempt on the South Pole.

By 1900, the first members of the team were appointed. Scott had insisted on personal approval of all appointments and was able to make quick decisions. With an idea of the hardship ahead, most were young and fit, though when Scott met Edward Wilson, a young doctor and artist, the man was suffering from an abscess in his armpit, blood poisoning, and lungs weakened by tuberculosis.

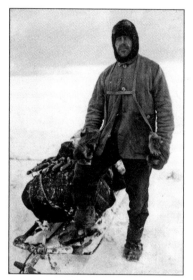
Robert Scott

Nonetheless, Scott appointed him. He also chose one Ernest Shackleton, whose own courageous story would become famous later on.

With the money Sir Clements Markham had raised, the ship *Discovery* was built, costing about $92,000, and launched on March 21, 1901. Scott also purchased a balloon for the voyage, which cost about $2,400. The young British king and queen, Edward VII and Alexandra, came on board to see the ship at Cowes. Sir Clements Markham said of the crew, "No finer set of men ever left these shores, nor were men ever led by a finer captain."

The trip south was slow and difficult. *Discovery* leaked and could not make more than seven knots under full steam. However, the men reached New Zealand, had the leak fixed, and took on supplies. They sailed on into the ice packs and the high southern latitudes. Scott and Shackleton were the first people ever to make a balloon trip in the Antarctic, though the balloon too developed a leak and was used only once.

The men's lack of experience showed in a number of ways, from misjudging distances and the difficulties of driving dogs to protecting the skin and cooking in low temperatures. They had to learn vital skills very quickly in an environment where sweat froze and a blizzard could strike without warning. However, they did learn, spending a year in an icy landscape, out of which their ship seemed to grow.

In November 1902 they made a push to the Pole, but the dogs sickened. They were the first to cross the 80th parallel, after which all maps were blank. They began to kill the dogs, feeding them to the others. Shackleton developed the first symptoms of scurvy due to a lack of vitamins in his diet, and the pain of snow blindness became so great for Wilson that he had to use a blindfold and follow Scott's voice. After an attempt lasting ninety-three days, they were 480 miles from the Pole when Scott gave the order to turn back on December 31. More dogs died on the way back to the ship, but the men all survived to try again.

A support ship, the *Morning*, resupplied the expedition and took some members home, including Shackleton. Research trips continued, despite temperatures as low as –67°F. The *Discovery* had become solidly wedged, and it took a combination of relief ships and dynamite to free it after two years on the ice. They returned to Portsmouth in September 1904. Still on special leave from the Royal Navy, Scott was appointed captain on the strength of his achievements. There were exhibitions of drawings and

scientific samples, lectures, and tours. Scott became something of a celebrity, publishing a two-volume account of the expedition, complete with Wilson's dramatic pictures. Despite his relative success, the government ignored Scott's plea to save the *Discovery* and it was sold.

In 1907 Scott went back to sea as captain on various ships. He met and married Kathleen Bruce in 1908. Shackleton tried a trip of his own, but his team turned back when they were only ninety-seven miles from the Pole. The lure of the Antarctic had struck deep in both Scott and Shackleton, but it was Scott's second expedition of 1910 that was to become famous around the world.

Scott wrote that "the main object of the expedition is to reach the South Pole and secure for the British Empire the honour of that achievement." Science would play a lesser part in the second strike for the Pole.

Scott had learned from his previous experiences and consulted once again with Nansen while the money was raised and the team came together. Funds came slowly, and more than one member of the expedition collected money to earn his place. Captain L. E. G. Oates was in charge of ponies. Wilfred Bruce, Scott's brother-in-law, was sent to Russia to buy the vital sled dogs and Siberian ponies. They also experimented with motorized sleds.

The Norwegian explorer Roald Amundsen was also heading south. Originally, his intentions had been to explore the Arctic, but an American, Robert Peary, claimed

to have reached the North Pole in 1909 and Amundsen now had his sights set on the unconquered southern pole. He had a hundred dogs with him and supplies for two years. He knew the conditions, and he had planned the route. Scott was still struggling to collect funds in New Zealand and Australia. The final stores were loaded and the ship *Terra Nova* sailed on November 29, 1910. Two months before, Scott had received a telegram from Amundsen, sent after he had sailed. It had read only, "Beg leave inform you proceeding Antarctic. Amundsen."

Terra Nova entered the pack ice on December 9, smashing its way through and finally anchoring to solid ice in January 1911. The sleds, base equipment, and supplies were unloaded—and the heaviest sled broke through the ice, disappearing into the sea. The slow process of a pole attempt began, with camps established farther and farther south. The ponies did not do at all well and frostbite appeared very early on among the men.

Conditions were awful, with constant blizzards pinning them in their tents. The ponies were all dead by the time they reached the last camp, after dragging the sleds

Captain L. E. G. Oates

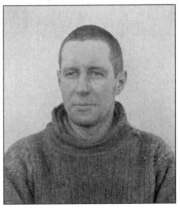

up a 10,000-foot glacier. Scott picked Wilson, Evans, Oates, and Bowers for the final slog to the Pole, with each man hauling 200 pounds on sleds.

The smaller team of five battled through blizzards to reach the 89th parallel, the last before the Pole itself. It was shortly afterward that they crossed the tracks of Amundsen and his dog teams. Scott and the others were touched by despair, but went on regardless, determined to reach the Pole.

They finally stood at the southernmost point on earth on January 17, 1912. There they found a tent, with a piece of paper that bore the names of five men: Roald Amundsen, Olav Olavson Bjaaland, Sverre Hassel, Oscar Wisting, and Hilmer Hanssen. The note was dated December 14, 1911. The disappointment weighed heavily on all of them—there have been few closer races in history with so much at stake.

The return trip began well enough, but Evans had lost fingernails to the cold, Wilson had strained a tendon in his leg, Scott himself had a bruised shoulder, and Oates had the beginnings of gangrene in his toes. In such extreme conditions of exhaustion, even small wounds refused to heal. They had all paid a terrible price to come in second.

Food began to run short, and every supply dump they reached was a race against starvation and the cold. Oil ran low and freezing to death was a real possibility. Evans collapsed on February 16 and never fully recovered.

He struggled on the following day, but he could barely stand and died shortly afterward.

Wilson too was growing weak, so Scott and Bowers made camp by themselves in temperatures of −43°F.

On March 16 or 17, Oates said he could not go on and wanted to be left in his sleeping bag. He knew he was slowing them down, and that their only slim chance may have been vanishing. The next morning, there was a blizzard blowing. Oates stood up in the tent and said, "I am just going outside and may be some time."

Scott wrote in his diary, "We knew that poor Oates was walking to his death, but though we tried to dissuade him, we knew it was the act of a brave man and an English gentleman." Oates was not seen again, and his body has never been found.

By March 20, Scott knew he would lose his right foot to frostbite. They were only eleven miles from a camp, but a blizzard prevented them from moving on. Staying still, though, would be a slow death for the three men remaining. They had no oil and only two days of starvation rations left. They had run out of time and strength. Scott made the decision to try for the depot, but it was beyond them, and they did not leave that last position. Scott's final diary entry was, "It seems a pity, but I do not think that I can write more. R. Scott. For God's sake look after our people."

With the diary ended, Scott wrote letters to the families of those who had died, including a letter to his own wife, where he mentioned their only son.

I had looked forward to helping you to bring him up, but it is a satisfaction to know that he will be safe with you. . . . Make the boy interested in natural history if you can. It is better than games. They encourage it in some schools. I know you will keep him in the open air. Try to make him believe in a God, it is comforting . . . and guard him against indolence. Make him a strenuous man. I had to force myself into being strenuous, as you know—had always an inclination to be idle.

He also wrote a letter to the public, knowing that his body would be found.

We took risks, we knew we took them; things have come out against us, and therefore we have no cause for complaint, but bow to the will of providence, determined still to do our best to the last. . . . Had we lived, I should have had a tale to tell of the hardihood, endurance and courage of my companions which would have stirred the heart of every Englishman. These rough notes and our dead bodies must tell the tale, but surely, surely, a great rich country like ours will see that those who are dependent on us are properly provided for.

Scott knew that the expedition funds were crippled by debt, and his last thoughts were the fear that their loved ones would be made destitute by what was still owed. In fact, enough donations came in when the story was known to pay all debts and create grants for the children and wives of those who had perished.

The men were found frozen in their tent by the team surgeon, Atkinson, in November of that year. The diaries and letters were recovered, and a snow cairn was built over their last resting place ready for the day when the moving pack ice would ease them into the frozen sea. The search party looked for Oates without success, finally erecting a cross to him with the following inscription.

HEREABOUTS DIED A VERY GALLANT
GENTLEMAN, CAPTAIN L.E.G. OATES OF THE
INNISKILLING DRAGOONS. IN MARCH 1912,
RETURNING FROM THE POLE, HE WALKED
WILLINGLY TO HIS DEATH IN A BLIZZARD
TO TRY TO SAVE HIS COMRADES, BESET
BY HARDSHIP.

[F]or my own sake I do not regret this journey, which has shown that Englishmen can endure hardships, help one another, and meet death with as great a fortitude as ever in the past. —Robert Falcon Scott

THE DAILY MIRROR, Wednesday, May 21, 1913.

CAPTAIN SCOTT'S TOMB NEAR THE SOUTH POLE.

The Daily Mirror

24 Pages

THE MORNING JOURNAL WITH THE SECOND LARGEST NET SALE.

No. 2,987. Registered at the G.P.O. as a Newspaper. WEDNESDAY, MAY 21, 1913 One Halfpenny.

THE MOST WONDERFUL MONUMENT IN THE WORLD: CAPTAIN SCOTT'S SEPULCHRE ERECTED AMID ANTARCTIC WASTES.

It was within a mere eleven miles of One Ton camp, which would have meant safety to the Antarctic explorers, that the search party found the tent containing the bodies of Captain Scott, Dr. E. A. Wilson and Lieutenant H. R. Bowers. This is, perhaps, the most tragic note of the whole Antarctic disaster. Above is the cairn, surmounted with a cross, erected over the tent where the bodies were found. At the side are Captain Scott's skis placed upright in a small pile of frozen snow.—(Copyright in England. Droits de reproduction en France réservés.)

EXTRAORDINARY STORIES—PART ONE

18

THE TWELVE TABLES
OF ROMAN LAW

ONE OF THE reasons we look back so fondly on ancient Rome is that the culture was a beacon of civilization at a time in history when places like Britain were still dark, savage, and tribal. As early as the fifth century BC, laws were inscribed or painted onto twelve wooden tablets. The first ten were written by patricians, the ruling class; the final two were produced by patricians and plebeians, the common men of Rome. Later they were "set in stone" and achieved a revered status very similar to the Constitution of the United States. When Cicero was young, schoolboys were expected to memorize these laws as a matter of course.

In later centuries, this core of laws was amended, interpreted, and occasionally challenged by public law cases. Although the Roman writer Livy described them as "the fountain of all public and private law," they ran alongside a greater body of more complex common law created from cases. Julius Caesar was a public defender, as was Brutus, his assassin. The greatest Roman orator, Cicero, was no supporter of Caesar, but even he was impressed by the man's rhetoric and public debate. As well as martial skill, a rising young lion of Rome was expected to be able to speak well and have a grounding in the laws of the Roman state.

By the time Justinian became emperor of the Eastern Roman Empire in AD 527, the body of laws had become unwieldy and unnecessarily complex. With the help of the best legal minds of the day, Justinian rewrote the entire code in a form that would later become the foundation of modern law.

In the period of the British Empire, many laws had their origin in the Roman system. The customary laws of the Channel Islands, the law of Scotland, and the Roman-Dutch law in South Africa and Ceylon all relate back to the statutes and practices of Rome.

It is an impressive legacy. Sadly, the original text survives only in fragments and references, but we do have enough to produce the text below. The laws themselves were often brutal by modern standards and make fascinating reading.

THE TWELVE TABLES OF ROMAN LAW

Though all the world exclaim against me, I will say what I think: that single little book of the Twelve Tables, if anyone look to the fountains and sources of laws, seems to me, assuredly, to surpass the libraries of all the philosophers, both in weight of authority, and in plenitude of utility. —Cicero, *De Oratore*

TABLE I

1. If anyone summons a man before the magistrate, he must go. If the man summoned does not go, let the one summoning him call the bystanders to witness and then take him by force.
2. If he shirks or runs away, let the summoner lay hands on him.
3. If illness or old age is the hindrance, let the summoner provide a team. He need not provide a covered carriage with a pallet unless he chooses.
4. Let the protector of a landholder be a landholder; for one of the proletariat, let anyone that cares, be protector.
6–9. When the litigants settle their case by compromise, let the magistrate announce it. If they do not compromise, let them state each his own side of the case, in the *comitium* of the forum before noon. Afterward let them talk it out together, while both are present. After noon, in case either party has failed to appear, let the magistrate pronounce judgment in

favor of the one who is present. If both are present the trial may last until sunset but no later.

TABLE II

2. He whose witness has failed to appear may summon him by loud calls before his house every third day.

TABLE III

1. One who has confessed a debt, or against whom judgment has been pronounced, shall have thirty days to pay. After that forcible seizure of his person is allowed. The creditor shall bring him before the magistrate. Unless he pays the amount of the judgment or someone in the presence of the magistrate interferes in his behalf as protector, the creditor shall take him home and fasten him in stocks or fetters. He shall fasten him with not less than fifteen pounds of weight or, if he choose, with more. If the prisoner choose, he may furnish his own food. If he does not, the creditor must give him a pound of meal daily; if he choose he may give him more.
2. On the third market day, let them divide his body among them. If they cut more or less than each one's share it shall be no crime.
3. Against a foreigner the right in property shall be valid forever.

TABLE IV

1. A dreadfully deformed child shall be quickly killed.
2. If a father sell his son three times, the son shall be free from his father.
3. As a man has provided in his will in regard to his money and the care of his property, so let it be binding. If he has no heir and dies intestate, let the nearest agnate [relation by blood on his father's side] have the inheritance. If there is no agnate, let the members of his gens [family or tribe] have the inheritance.
4. If one is mad but has no guardian, the power over him and his money shall belong to his agnates and the members of his gens.
5. A child born after ten months since the father's death will not be admitted into a legal inheritance.

TABLE V

1. Females should remain in guardianship even when they have attained their majority.

TABLE VI

1. When one makes a bond and a conveyance of property, as he has made formal declaration, so let it be binding.
3. A beam that is built into a house or a vineyard trellis one may not take from its place.

5. *Usucapio* [ownership] of movable things requires one year's possession for its completion; but *usucapio* of an estate and buildings two years.

6. Any woman who does not wish to be subjected in this manner to the hand of her husband should be absent three nights in succession every year, and so interrupt the *usucapio* of each year.

TABLE VII

1. Let them keep the road in order. If they have not paved it, a man may drive his team where he likes.

9. Should a tree on a neighbor's farm be bent crooked by the wind and lean over your farm, you may take legal action for removal of that tree.

10. A man might gather up fruit that was falling down onto another man's farm.

TABLE VIII

2. If one has maimed a limb and does not compromise with the injured person, let there be retaliation. If one has broken a bone of a freeman with his hand or with a stick, let him pay a penalty of three hundred coins. If he has broken the bone of a slave, let him have one hundred and fifty coins. If one is guilty of insult, the penalty shall be twenty-five coins.

3. If one is slain while committing theft by night, he is rightly slain.

4. If a patron shall have devised any deceit against his client, let him be accursed.

5. If one shall permit himself to be summoned as a witness, but does not give his testimony, let him be noted as dishonest and incapable of acting again as witness.

10. Any person who destroys by burning any building or heap of corn deposited alongside a house shall be bound, scourged, and put to death by burning at the stake provided that he has committed the said misdeed with malice aforethought; but if he shall have committed it by accident, that is, by negligence, he must repair the damage. If he be too poor for such punishment, he shall receive a lighter punishment.

12. If the theft has been done by night, if the owner kills the thief, the thief shall be held to be lawfully killed.

13. It is unlawful for a thief to be killed by day unless he defends himself with a weapon. Even though he has come with a weapon, unless he shall use the weapon and fight back, you shall not kill him. And even if he resists, first call out so that someone may hear and come up.

23. A person who had been found guilty of giving false witness shall be hurled down from the Tarpeian Rock.

26. No person shall hold meetings by night in the city.

TABLE IX

4. The penalty shall be capital for a judge or arbiter legally appointed who has been found guilty of receiving a bribe for giving a decision.

5. Treason: he who shall have roused up a public enemy or handed over a citizen to a public enemy must suffer capital punishment.

6. Putting to death of any man, whosoever he might be unconvicted is forbidden.

TABLE X

1. None is to bury or burn a corpse in the city.

3. The women shall not tear their faces nor wail on account of the funeral.

5. If one obtains a crown himself, or if his chattel does so because of his honor and valor, if it is placed on his head, or the head of his parents, it shall be no crime.

TABLE XI

1. Marriages should not take place between plebeians and patricians.

TABLE XII

2. If a slave shall have committed theft or done damage with his master's knowledge, the action for damages is in the slave's name.

5. Whatever the people had last ordained should be held as binding by law.

SPIES—CODES AND CIPHERS

T HE PRACTICE OF sending secret messages is known as "steganography," Greek for "concealed writing." The problem with hiding a message in the lining of a coat or tattooed on the scalp is that anyone can read it. It makes a lot of sense to practice "cryptography," as well, Greek for "hidden writing." Cryptography is the art of writing or breaking codes and ciphers.

The words "code" and "cipher" are sometimes used as if they mean the same thing. They do not. A code is a substitution, such as the following sentence: "The Big Cheese lands at Happy tomorrow." We do not know who the Big Cheese is, or where Happy is. Codes were commonly used between spies in World War II, when groups of numbers could only be translated with the correct codebook. Codes are impossible to break without a key or detailed knowledge of the people involved. If you spied on a group for some months, however, noticing that the president of France landed at Heathrow airport the day after such a message, a pattern might begin to emerge.

Ciphers, on the other hand, are scrambled messages, not a secret language. In a cipher, a plain-text message is concealed by replacing the letters according to a pattern. Even Morse code is, in fact, a cipher. Ciphers are fascinating and even dangerous. More than one person has gone to his grave without giving up the secret of a particular

cipher. Treasures have been lost, along with lives spent searching for them. In time of war, thousands of lives can depend on ciphers being kept—or *deciphered*.

Edgar Allan Poe left behind a cipher that was broken in the year 2000. The composer Edward Elgar left a message for a young lady that has not yet been fully understood. Treasure codes exist that point the way to huge sums in gold—if only the sequence of symbols can be broken.

At the time of writing, the state-of-the-art cipher is a computer sequence with 2,048 figures, each of which can be a number, letter, or symbol. The combinations are in trillions of trillions, and it is estimated that even the fastest computers in the world couldn't break it in less than thirty billion years. Oddly enough, it was created by a seventeen-year-old boy in Kent, named Peter Parkinson. He is quite pleased with it. To put it in perspective, it is illegal in America to export an encryption program with more than *forty* digits without providing a key. It takes three days to break a fifty-six-bit encryption.

Combinations to computer locks are one thing. This chapter contains some classic ciphers—starting with the one used by Julius Caesar to send messages to his generals.

1. **The Caesar Shift Cipher.** This is a simple alphabet cipher, but tricky to break without the key. Each letter is moved along by a number—say four. A becomes E, J becomes N, Z becomes D, and so on. The number is the key to the cipher here. Caesar could agree on the number with his generals in private and then send encrypted

messages knowing they could not be read without that crucial extra piece of information.

"The dog is sick" becomes "WKH GRJ LV VLFN," with the number three as the key.

As a first cipher it works well, but the problem is that there are only twenty-five possible number choices (twenty-six would take you back to the letter you started with). As a result, someone who really wanted to break the code could simply plod their way through all twenty-five combinations. Admittedly, they would first have to recognize the code as a Caesar cipher, but this one only gets one star for difficulty—it is more than two thousand years old, after all.

2. **Numbers.** A=1, B=2, C=3, etc., all the way to Z=26. Messages can be written using those numbers. This cipher is probably too simple to use on its own; however, if you combine it with a Caesar code number, it can suddenly become very tricky indeed.

In the basic method, "The dog is better" would be "20 8 5–4 15 7–9 19–2 5 20 20 5 18," which looks difficult but isn't. Add a Caesar cipher of 3, however, and the message becomes "3 23 11 8–7 18 10–12 22–5 8 23 23 8 21," which should overheat the brain of younger brothers or sisters trying to break the encryption. Note that we have included the key number at the beginning. It could be agreed beforehand in private to make this even harder to break. (With the Caesar combination, a difficulty of two stars.)

3. **Alphabet Ciphers.** There are any number of these. Most of them depend on the way the alphabet is written out—agreed on beforehand between the spies.

A B C D E F G H I J K L M

N O P Q R S T U V W X Y Z

With this sequence, "How are you?" would become "UBJ NER LBH?"

A B C D E F G H I J K L M N O P Q R S T U V W X Y Z

Z Y X W V U T S R Q P O N M L K J I H G F E D C B A

In this one, "How are you?" would become "SLD ZIV BLF?" It's worth remembering that even simple ciphers are not obvious at first glance. Basic alphabet ciphers may be enough to protect a diary, and they have the benefit of being easy to use and remember.

4. Most famous of the alphabet variations is a **code stick**—another one used by the Romans. Begin with a strip of paper and wind it around a stick. It is important that the sender and the receiver both have the same type of stick. Two bits from the same broom handle would be perfect, but most people end up trying this on a pencil (see picture).

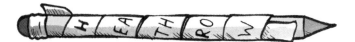

Here the word "Heathrow" is written down the length of the pencil, with a couple of letters per turn of the strip. (You'll need to hold the paper steady with tape.) When the tape is unwound, the same pen is used to fill in the spaces between the letters. The tape should now look like gibberish. The idea is that when it is wound back on to a similar stick, the message will be clear. It is a cipher that requires a bit of forethought, but can be quite satisfying. For a matter of life and death, however, you may need the next method.

5. **Codeword Alphabet Substitution.** You might have noticed a pattern developing here. To make a decent cipher, it is a good idea to agree on the key beforehand. It could be a number, a date, the title of a book, a word, or even a kind of stick. It's the sort of added complexity that can make even a simple encryption quite fiendish.

Back to one of our earlier examples:

A B C D E F G H I J K L M N O P Q R S T U V W X Y Z

Z Y X W V U T S R Q P O N M L K J I H G F E D C B A

If we added the word "window," we would get the next sequence. Note that no letters are repeated, so there are still twenty-six in the bottom sequence and the second "W" of "window" is not used.

A B C D E F G H I J K L M N O P Q R S T U V W X Y Z

W I N D O A B C E F G H J K L M P Q R S T U V X Y Z

This is a whole new cipher, and without knowing the codeword, a difficulty of three stars to crack.

6. **Cipher-wheels.** Using a pair of compasses, cut four circles out of card, two large and two small—5 inch (12 cm) and 4 inch (10 cm) diameters work well. For both pairs, put one on top of the other and punch a hole through with a butterfly stud. They should rotate easily.

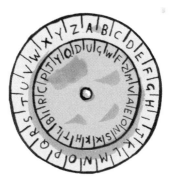

A circle is divided into 360 degrees. There are twenty-six letters in the alphabet, so the spacing for the segments should be approximately 14 degrees. Mark off the segments as accurately as you can for all four circles. When they are ready, write the normal alphabet around the outside of the large circles in the usual way: A to Z. For the inner circles, mark the letters in random order. As long as the matching code wheel is done in the same

way, it doesn't matter where the letters go. The code sequence will begin with the two-letter combination that shows the positions of the wheels—AM or AF, for example.

You should end up with a cipher-wheel encrypter that can *only* be read by someone with the other wheel. Now *that* is a difficulty of four stars.

7. **Morse Code** is the most famous substitution cipher ever invented. It was thought up by an American inventor, Samuel F. B. Morse, who patented a telegraph system and saw it explode in popularity. He realized that a pulse of electricity could act on an electromagnet to move a simple lever, transmitting a long or short signal. He arranged a moving strip of paper to pass underneath the metal point, and a new method of communication was born. Using his cipher, he sent the first intercity message in 1844 from Washington to Baltimore. The marvelous thing about it is that the code can be sent using light if you have a flashlight, or sound, if you can reach a car horn, or even semaphore, although that is fairly tricky.

The first message Morse sent was "What hath God wrought?" which gives an idea of just how impressive it was to pick up messages as they were written on the other side of the United States. In Morse's lifetime, he saw telegraph lines laid across the Atlantic.

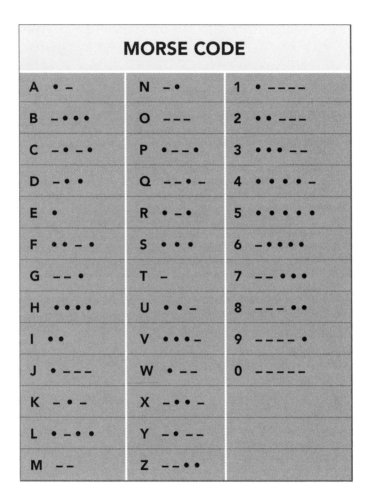

MORSE CODE

A	• –	N	– •	1	• – – – –
B	– • • •	O	– – –	2	• • – – –
C	– • – •	P	• – – •	3	• • • – –
D	– • •	Q	– – • –	4	• • • • –
E	•	R	• – •	5	• • • • •
F	• • – •	S	• • •	6	– • • • •
G	– – •	T	–	7	– – • • •
H	• • • •	U	• • –	8	– – – • •
I	• •	V	• • • –	9	– – – – •
J	• – – –	W	• – –	0	– – – – –
K	– • –	X	– • • –		
L	• – • •	Y	– • – –		
M	– –	Z	– – • •		

The example *everyone* knows is SOS—the international distress call. ("Mayday" is also well known. That one comes from the French for "Help me"—*M'aider*.)

The SOS sequence in Morse is dit dit dit—dah dah dah—dit dit dit.

This really is one worth learning. Rescuers have heard messages tapped out underneath fallen buildings, heard whistles, or seen the flashes from a capsized dinghy. This cipher has saved a large number of lives over the years since its invention. It has also sent quite a few train timetables.

If you *do* have a flag handy, it's left for a dash, right for a dot. This is not so well known.

8. This last one is actually designed to make meaning clearer rather than to hide it. The **NATO phonetic alphabet** is just useful to know.

The NATO version was created in 1956 and has become the accepted standard phonetic alphabet. It is used to minimize confusion when reading letters aloud on the radio or telephone. "P" and "B" sound very similar, but "Papa" and "Bravo" do not.

NATO PHONETIC ALPHABET

A	Alpha	N	November
B	Bravo	O	Oscar
C	Charlie	P	Papa
D	Delta	Q	Quebec
E	Echo	R	Romeo
F	Foxtrot	S	Sierra
G	Golf	T	Tango
H	Hotel	U	Uniform
I	India	V	Victor
J	Juliet	W	Whiskey
K	Kilo	X	X-ray
L	Lima	Y	Yankee
M	Mike	Z	Zulu

Even in these days of radio and satellite communications, the U.S. Navy uses the international alphabet flags, numeral pennants, numeral flags, and special flags and pennants for visual signaling. These signal flags are used to communicate while maintaining radio silence. Navy signalmen transmit messages by hoisting a flag or a series of flags on a halyard. Each side of the ship has halyards and a "flag bag," containing a full set of signal flags. Signals unique to the navy are used when communicating with other U.S. Navy or allied forces. When communicating with all other vessels, the International Code of Signals is used. The code/answer pennant precedes all signals in international code.

Flag	Name	Phonetic Pronunciation	Navy Meaning	International Meaning
	ALFA	*AL-fah*	I have a diver down; keep well clear at slow speed.	
	BRAVO	*BRAH-voh*	I am taking in, discharging, or carrying dangerous cargo.	

(Continued)

Flag	Name	Phonetic Pronunciation	Navy Meaning	International Meaning
	CHARLIE	*CHAR-lee*	"Yes" or "affirmative."	
	DELTA	*DELL-tah*	I am maneuvering with difficulty; keep clear.	
	ECHO	*ECK-oh*	I am directing my course to starboard.	
	FOXTROT	*FOKS-trot*	I am disabled; communicate with me.	On aircraft carriers: flight operations under way.
	GOLF	*GOLF*	I require a pilot.	
	HOTEL	*hoh-TELL*	I have a pilot on board.	
	INDIA	*IN-dee-ah*	Coming alongside.	I am directing my course to port.
	JULIET	*JEW-lee-ett*	I am on fire and have dangerous cargo; keep clear.	

(Continued)

Flag	Name	Phonetic Pronunciation	Navy Meaning	International Meaning
	KILO	*KEY-loh*	I wish to communicate with you.	
	LIMA	*LEE-mah*	You should stop your vessel immediately.	
	MIKE	*MIKE*	My vessel is stopped; making no way.	
	NOVEMBER	*no-VEM-bur*	"No" or "negative."	
	OSCAR	*OSS-kur*	Man overboard.	
	PAPA	*pah-PAH*	All personnel return to ship; proceeding to sea (in port).	
	QUEBEC	*kay-BECK*	Boat recall; all boats return to ship	Ship meets health regs; request clearance into port.
	ROMEO	*ROH-me-oh*	Preparing to replenish (at sea). Ready duty ship (in port).	

(Continued)

Flag	Name	Phonetic Pronunciation	Navy Meaning	International Meaning
	SIERRA	*see-AIR-ah*	Conducting flag hoist drill.	Moving astern.
	TANGO	*TANG-go*	Do not pass ahead of me.	Keep clear; engaged in trawling.
	UNIFORM	*YOU-nee-form*	You are running into danger.	
	VICTOR	*VIK-tah*	I require assistance.	
	WHISKEY	*WISS-kee*	I require medical assistance.	
	XRAY	*ECKS-ray*	Stop carrying out your intentions and watch for my signals.	
	YANKEE	*YANG-kee*	Ship has visual communications duty.	I am dragging anchor.
	ZULU	*ZOO-loo*	I require a tug.	
				(Continued)

Flag	Name	Phonetic Pronunciation	Navy Meaning	International Meaning
	ONE	*WUN*	Numeral one.	
	TWO	*TOO*	Numeral two.	
	THREE	*TREE*	Numeral three.	
	FOUR	*FOW-er*	Numeral four.	
	FIVE	*FIFE*	Numeral five.	
	SIX	*SICKS*	Numeral six.	
	SEVEN	*SEV-en*	Numeral seven.	
	EIGHT	*AIT*	Numeral eight.	

(Continued)

Flag	Name	Phonetic Pronunciation	Navy Meaning	International Meaning
	NINE	*NIN-er*	Numeral nine.	
	ZERO	*ZEE-roh*	Numeral zero.	

Navajo Code Talkers' Dictionary

During World War II, the U.S. Marines needed a code for their missions on the Pacific front. They discovered the language of the Navajo, which was especially suited for coding because it had no written alphabet, was only spoken in the American Southwest, and is incredibly complex.

When the war broke out, there were fewer than thirty non-Navajo people who could speak the language, none of whom were Japanese. At the time, it would take a machine half an hour to encode a three-line message in English. Navajo code talkers could do the same job in twenty seconds.

The Navajo Code Talkers' Dictionary was developed at Camp Pendleton in Oceanside, California. All Navajo recruits had to learn the code words by heart; throughout the war, they were praised for their speed and precision. The Japanese were known to be excellent code

breakers, but even they couldn't decipher the Navajo code. While the Japanese managed to intercept messages from the U.S. Army and the Army Air Corps, they were never able to figure out what the marines were telling one another.

"Were it not for the Navajos," said Major Howard Connor, Fifth Marine Division signal officer, "the marines would never have taken Iwo Jima."

NAVAJO CODE TALKERS' ALPHABET

Alphabet	Navajo Word	Literal Translation
A	WOL-LA-CHEE	Ant
A	BE-LA-SANA	Apple
A	TSE-NILL	Ax
B	NA-HASH-CHID	Badger
B	SHUSH	Bear
B	TOISH-JEH	Barrel
C	MOASI	Cat
C	TLA-GIN	Coal
C	BA-GOSHI	Cow
D	BE	Deer
D	CHINDI	Devil
D	LHA-CHA-EH	Dog
E	AH-JAH	Ear

(Continued)

Alphabet	Navajo Word	Literal Translation
E	DZEH	Elk
E	AH-NAH	Eye
F	CHUO	Fir
F	TSA-E-DONIN-EE	Fly
F	MA-E	Fox
G	AH-TAD	Girl
G	KLIZZIE	Goat
G	JEHA	Gum
H	TSE-GAH	Hair
H	CHA	Hat
H	LIN	Horse
I	TKIN	Ice
I	YEH-HES	Itch
I	A-CHI	Intestine
J	TKELE-CHO-G	Jackass
J	AH-YA-TSINNE	Jaw
J	YIL-DOI	Jerk
K	JAD-HO-LONI	Kettle
K	BA-AH-NE-DI-TININ	Key
K	KLIZZIE-YAZZIE	Kid
L	DIBEH-YAZZIE	Lamb
L	AH-JAD	Leg

(Continued)

Alphabet	Navajo Word	Literal Translation
L	NASH-DOIE-TSO	Lion
M	TSIN-TLITI	Match
M	BE-TAS-TNI	Mirror
M	NA-AS-TSO-SI	Mouse
N	TSAH	Needle
N	A-CHIN	Nose
O	A-KHA	Oil
O	TLO-CHIN	Onion
O	NE-AHS-JAH	Owl
P	CLA-GI-AIH	Pant
P	BI-SO-DIH	Pig
P	NE-ZHONI	Pretty
Q	CA-YEILTH	Quiver
R	GAH	Rabbit
R	DAH-NES-TSA	Ram
R	AH-LOSZ	Rice
S	DIBEH	Sheep
S	KLESH	Snake
T	D-AH	Tea
T	A-WOH	Tooth
T	THAN-ZIE	Turkey
U	SHI-DA	Uncle

(*Continued*)

Alphabet	Navajo Word	Literal Translation
U	NO-DA-IH	Ute
V	A-KEH-DI-GLINI	Victor
W	GLOE-IH	Weasel
X	AL-NA-AS-DZOH	Cross
Y	TSAH-AS-ZIH	Yucca
Z	BESH-DO-TLIZ	Zinc

NAVAJO CODE TALKERS' DICTIONARY

English Term	Navajo Word	Literal Translation
CORPS	DIN-NEH-IH	Clan
BATTALION	TACHEENE	Red soil
PLATOON	HAS-CLISH-NIH	Mud
COMMANDING GENERAL	BIH-KEH-HE (G)	War chief
AMERICA	NE-HE-MAH	Our mother
BRITAIN	TOH-TA	Between waters
PLANES	WO-TAH-DE-NE-IH	Air force
DIVE BOMBER	GINI	Chicken hawk
BATTLESHIP	LO-TSO	Whale
		(Continued)

English Term	Navajo Word	Literal Translation
SUBMARINE	BESH-LO	Iron fish
ANTICIPATE	NI-JOL-LIH	Anticipate
APPROACH	BI-CHI-OL-DAH	Approach
BATTLE	DA-AH-HI-DZI-TSIO	Battle
BEACH	TAH-BAHN (B)	Beach
BOMB	A-YE-SHI	Eggs
BOOBY TRAP	DINEH-BA-WHOA-BLEHI	Mantrap
CAMP	TO-ALTSEH-HOGAN	Temporary place
CAMOUFLAGE	DI-NES-IH	Hid
CAPTURE	YIS-NAH	Capture
COUNTER-ATTACK	WOLTAH-AL-KI-GI-JEH	Counteract
DEFENSE	AH-KIN-CIL-TOH	Defense
ENGINE	CHIDI-BI-TSI-TSINE (E)	Engine
FORTIFY	AH-NA-SOZI-YAZZIE	Small fortification
GRENADE	NI-MA-SI	Potatoes

(Continued)

English Term	Navajo Word	Literal Translation
GUARD	NI-DIH-DA-HI	Guard
HIGHWAY	WO-TAH-HO-NE-TEH	Highway
HOWITZER	BE-EL-DON-TS-QUODI	Short big gun
IMPORTANT	BA-HAS-TEH	Important
INTELLIGENCE	HO-YA (I)	Smart
JUNGLE	WOH-DI-CHIL	Jungle
LEADER	AH-NA-GHAI	Leader
LEAVE	DAH-DE-YAH	He left
LOCATE	A-KWE-EH	Spot
MACHINE GUN	A-KNAH-AS-DONIH	Rapid-fire gun
MANEUVER	NA-NA-O-NALTH	Moving around
MAP	KAH-YA-NESH-CHAI	Map
PARTY	DA-SHA-JAH	Party
PHOTOGRAPH	BEH-CHI-MA-HAD-NIL	Photograph
PLANE	TSIDI	Bird
RADAR	ESAT-TSANH (R)	Listen
RAILROAD	KONH-NA-AL-BANSI-BI-THIN	Railroad

(Continued)

English Term	Navajo Word	Literal Translation
SAILOR	CHA-LE-GAI	White caps
SCOUT	HA-A-SID-AL-SIZI-GIH	Short raccoon
SECRET	BAH-HAS-TKIH	Secret
SMOKE	LIT	Smoke
SNIPER	OH-BEHI	Pick 'em off
SPEED	YO-ZONS	Swift motion
SQUADRON	NAH-GHIZI	Squash
SUCCESS	UT-ZAH	It is done
TANK	CHAY-DA-GAHI	Tortoise
TARGET	WOL-DONI	Target
TEAM	DEH-NA-AS-TSO-SI	Tea mouse
TROOP	NAL-DEH-HI	Troop
TRUCK	CHIDO-TSO	Big auto
WARNING	BILH-HE-NEH (W)	Warning
WATER	TKOH	Water

FIVE POEMS EVERY BOY
SHOULD KNOW

———✶———

Y ES, A BOY should be able to climb trees, grow crystals, and tie a decent bowline knot. However, a boy will grow into a man and no man should be completely ignorant of these poems. They are the ones that spoke to us when we were young. Find a big tree and climb it. Read one of these poems aloud to yourself, high in the branches. All the authors are long dead, but they may still speak to you.

If

BY RUDYARD KIPLING (1865–1936)

If you can keep your head when all about you
* Are losing theirs and blaming it on you,*
If you can trust yourself when all men doubt you,
* But make allowance for their doubting too;*
If you can wait and not be tired by waiting,
* Or being lied about, don't deal in lies,*
Or being hated, don't give way to hating,
* And yet don't look too good, nor talk too wise:*

If you can dream—and not make dreams your master;
* If you can think—and not make thoughts your aim;*

If you can meet with Triumph and Disaster
And treat those two impostors just the
same;
If you can bear to hear the truth you've spoken
Twisted by knaves to make a trap for fools,
Or watch the things you gave your life to, broken,
And stoop and build 'em up with worn-out tools:

If you can make one heap of all your winnings
And risk it on one turn of pitch-and-toss,
And lose, and start again at your beginnings
And never breathe a word about your loss;
If you can force your heart and nerve and sinew
To serve your turn long after they are gone,
And so hold on when there is nothing in you
Except the Will which says to them: "Hold on!"

If you can talk with crowds and keep your virtue,
Or walk with Kings—nor lose the common touch,
If neither foes nor loving friends can hurt you,
If all men count with you, but none too much;
If you can fill the unforgiving minute
With sixty seconds' worth of distance run,
Yours is the Earth and everything that's in it,
And—which is more—you'll be a Man, my son!

We recommend *Puck of Pook's Hill* as an example of Kipling's prose. Tragically, his only son John was killed in World War I, in 1915.

Ozymandias

BY PERCY BYSSHE SHELLEY (1792–1822)

I met a traveller from an antique land
Who said: Two vast and trunkless legs of stone
Stand in the desert . . . Near them, on the sand,
Half sunk, a shattered visage lies, whose frown,
And wrinkled lip, and sneer of cold command,
Tell that its sculptor well those passions read
Which yet survive, stamped on these lifeless things,
The hand that mocked them, and the heart that fed:
And on the pedestal these words appear:
"My name is Ozymandias, king of kings:
Look on my works, ye Mighty, and despair!"
Nothing beside remains. Round the decay
Of that colossal wreck, boundless and bare
The lone and level sands stretch far away.

This poem was written as a commentary on human arrogance. It is based on a broken statue near Luxor, Egypt. The actual inscription (translated) reads "King of Kings am I, Osymandias. If anyone would know how great I am and where I lie, let him surpass one of my works."

Invictus

BY WILLIAM ERNEST HENLEY (1849–1903)

Out of the night that covers me,
 Black as the pit from pole to pole,
I thank whatever gods may be
 For my unconquerable soul.

In the fell clutch of circumstance
 I have not winced nor cried aloud.
Under the bludgeonings of chance
 My head is bloody, but unbowed.

Beyond this place of wrath and tears
 Looms but the Horror of the shade,
And yet the menace of the years
 Finds, and shall find, me unafraid.

It matters not how strait the gate,
 How charged with punishments the scroll,
I am the master of my fate:
 I am the captain of my soul.

"Invictus" is Latin for "unconquerable." As a child, Henley suffered the amputation of a foot. He was ill for much of his life and wrote this during a two-year spell in an infirmary. He was a great friend of Robert Louis Stevenson and the character of Long John Silver may even be based on him.

Sea-Fever

BY JOHN MASEFIELD (1878–1967)

I must down to the seas again, to the lonely sea and the sky,
And all I ask is a tall ship and a star to steer her by,
And the wheel's kick and the wind's song and the white
 sails shaking,
And a grey mist on the sea's face and a grey dawn breaking.

I must down to the seas again, for the call of the running
 tide
Is a wild call and a clear call that may not be denied;
And all I ask is a windy day with the white clouds flying,
And the flung spray and the blown spume, and the
 sea-gulls crying.

I must down to the seas again, to the vagrant gypsy life,
To the gull's way and the whale's way where the wind's
 like a whetted knife;
And all I ask is a merry yarn from a laughing
 fellow-rover,
And quiet sleep and a sweet dream when the long trick's
 over.

Masefield, who later became poet laureate of England, wrote "Sea-Fever" when he was only twenty-two. It contains some fantastic examples of onomatopoeia—words that sound like their meaning. You can hear the wind in "wind's like a whetted knife," for example.

Song of Myself

BY WALT WHITMAN (1819–1892)

From 1

I celebrate myself, and sing myself,
And what I assume you shall assume,
For every atom belonging to me as good belongs to you.

I loafe and invite my soul,
I lean and loafe at my ease observing a spear of summer
grass.

From 2

Have you reckon'd a thousand acres much? have you
reckon'd the earth much?
Have you practis'd so long to learn to read?
Have you felt so proud to get at the meaning of poems?

Stop this day and night with me and you shall possess
the origin of all poems,
You shall possess the good of the earth and sun, (there
are millions of suns left,)
You shall no longer take things at second or third hand,
nor look through
the eyes of the dead, nor feed on the spectres in books,
You shall not look through my eyes either, nor take things
from me,
You shall listen to all sides and filter them from your self.

From 47

I am the teacher of athletes,
He that by me spreads a wider breast than my own
* proves the width of my own,*
He most honors my style who learns under it to destroy
* the teacher.*

The boy I love, the same becomes a man not through
* derived power, but in his own right,*
Wicked rather than virtuous out of conformity or fear,
Fond of his sweetheart, relishing well his steak,
Unrequited love or a slight cutting him worse than sharp
* steel cuts,*
First-rate to ride, to fight, to hit the bull's eye, to sail a
skiff, to sing a song or play on the banjo,
Preferring scars and the beard and faces pitted with
* small-pox over all latherers,*
And those well-tann'd to those that keep out of the sun.

From 50

There is that in me—I do not know what it is—but I know
* it is in me.*

From 52

The spotted hawk swoops by and accuses me, he
* complains of my gab and my loitering.*

I too am not a bit tamed, I too am untranslatable,
I sound my barbaric yawp over the roofs of the world.

Walt Whitman's *Song of Myself* has fifty-two stanzas, and we have reproduced only a small bit of it here. If you would like to read more—and if you're at all like us, you will—you can easily find it in your local library.

There are hundreds more poems that have stayed with us as we grow older. That is the magic perhaps, that a single line can bring comfort in grief, or express the joy of a birth. These are not small things.

PRESIDENTS AND VICE PRESIDENTS OF THE UNITED STATES

—✦—

E VERY FOUR YEARS the United States elects a president and a vice president. The nominee must be at least thirty-five years old, a native-born citizen of the United States, and must have been a resident of the country for no less than fourteen years.

President	Party	Term as President	Vice President
1. George Washington (1732–1799)	None, Federalist	1789–1797	John Adams
2. John Adams (1735–1826)	Federalist	1797–1801	Thomas Jefferson
3. Thomas Jefferson (1743–1826)	Democratic–Republican	1801–1809	Aaron Burr, George Clinton
4. James Madison (1751–1836)	Democratic–Republican	1809–1817	George Clinton, Elbridge Gerry
5. James Monroe (1758–1831)	Democratic–Republican	1817–1825	Daniel Tompkins
6. John Quincy Adams (1767–1848)	Democratic–Republican	1825–1829	John Calhoun
7. Andrew Jackson (1767–1845)	Democrat	1829–1837	John Calhoun, Martin van Buren *(Continued)*

President	Party	Term as President	Vice President
8. Martin van Buren (1782–1862)	Democrat	1837–1841	Richard Johnson
9. William H. Harrison (1773–1841)	Whig	1841	John Tyler
10. John Tyler (1790–1862)	Whig	1841–1845	
11. James K. Polk (1795–1849)	Democrat	1845–1849	George Dallas
12. Zachary Taylor (1784–1850)	Whig	1849–1850	Millard Fillmore
13. Millard Fillmore (1800–1874)	Whig	1850–1853	
14. Franklin Pierce (1804–1869)	Democrat	1853–1857	William King
15. James Buchanan (1791–1868)	Democrat	1857–1861	John Breckinridge
16. Abraham Lincoln (1809–1865)	Republican	1861–1865	Hannibal Hamlin, Andrew Johnson
17. Andrew Johnson (1808–1875)	National Union	1865–1869	
18. Ulysses S. Grant (1822–1885)	Republican	1869–1877	Schuyler Colfax
19. Rutherford Hayes (1822–1893)	Republican	1877–1881	William Wheeler
20. James Garfield (1831–1881)	Republican	1881	Chester Arthur

(Continued)

President	Party	Term as President	Vice President
21. Chester Arthur (1829–1886)	Republican	1881–1885	
22. Grover Cleveland (1837–1908)	Democrat	1885–1889	Thomas Hendriks
23. Benjamin Harrison (1833–1901)	Republican	1889–1893	Levi Morton
24. Grover Cleveland (1837–1908)	Democrat	1893–1897	Adlai Stevenson
25. William McKinley (1843–1901)	Republican	1897–1901	Garret Hobart, Theodore Roosevelt
26. Theodore Roosevelt (1858–1919)	Republican	1901–1909	Charles Fairbanks
27. William Taft (1857–1930)	Republican	1909–1913	James Sherman
28. Woodrow Wilson (1856–1924)	Democrat	1913–1921	Thomas Marshall
29. Warren Harding (1865–1923)	Republican	1921–1923	Calvin Coolidge
30. Calvin Coolidge (1872–1933)	Republican	1923–1929	Charles Dawes
31. Herbert C. Hoover (1874–1964)	Republican	1929–1933	Charles Curtis
32. Franklin Delano Roosevelt (1882–1945)	Democrat	1933–1945	John Garner, Henry Wallace, Harry S. Truman

(Continued)

President	Party	Term as President	Vice President
33. Harry S. Truman (1884–1972)	Democrat	1945–1953	Alben Barkley
34. Dwight David Eisenhower (1890–1969)	Republican	1953–1961	Richard Milhous Nixon
35. John Fitzgerald Kennedy (1917–1963)	Democrat	1961–1963	Lyndon Baines Johnson
36. Lyndon Baines Johnson (1908–1973)	Democrat	1963–1969	Hubert Humphrey
37. Richard Milhous Nixon (1913–1994)	Republican	1969–1974	Spiro Agnew, Gerald R. Ford
38. Gerald R. Ford (1913–2006)	Republican	1974–1977	Nelson Rockefeller
39. James (Jimmy) Earl Carter Jr. (1924–)	Democrat	1977–1981	Walter Mondale
40. Ronald Wilson Reagan (1911–2004)	Republican	1981–1989	George H. W. Bush
41. George H. W. Bush (1924–)	Republican	1989–1993	James Danforth (Dan) Quayle
42. William (Bill) Jefferson Clinton (1946–)	Democrat	1993–2001	Al Gore
43. George W. Bush (1946–)	Republican	2001–2008	Richard Cheney

Source: Enchangedlearning.com

THE RULES OF SOCCER

———✦———

NEATLY ENOUGH, THERE are only seventeen main laws for the most popular game on earth. These are based on rules put together in England as far back as 1863 and formally ratified by the International Football Association Board in 1886.

1. **The pitch.** Length: 100–130 yds. (90 m–120 m). Width: 50–100 yds. (45 m–90 m). The two long lines are called touchlines, the two short lines are called goal lines. The pitch is divided by a halfway line, with a center point where the "kick-off" occurs to begin the match. At each goal, there is a 6-yd. box (5.5 m) known as the goal area. Outside that, there is an 18-yd. box (16.5 m) known as the penalty area. A penalty spot is drawn 12 yds. (11 m) in front of the goalposts. The goalposts are 8 yds. (7.32 m) apart and 8 ft. (2.44 m) high.

2. **The ball.** Circumference: between 27 and 28 in. (68–70 cm). Weight: between 14 and 16 oz. (410–450 g).

3. **The teams.** No more than eleven players can be fielded by each team, including the goalkeeper. Depending on the competition, between three and seven substitutes can be used. In addition, any player can change places

with the goalkeeper provided that the referee is told, and the change occurs while play has stopped.

4. **Clothing.** Players wear regulation shirts, shorts, shin-guards under long socks, and soccer cleats. Goalkeepers wear different colored uniforms.

5. **The referee.** All decisions by the referee are final. Powers include the ability to give a verbal warning, a more serious yellow card warning, or a red card, which results in immediate sending off the field. A second yellow card is equivalent to a red. The referee also acts as timekeeper for the match and controls any restarts after stopped play.

6. **Assistant referees** (linesmen). These indicate with a raised flag when a ball has crossed the lines and gone out of play, and let the referee know which side is to take the corner, goal kick, or throw-in. They also raise their flags to indicate when a player may be penalized for being in an offside position.

7. **Duration.** Two halves of forty-five minutes, with a half-time interval of no more than fifteen minutes.

8. **Starting.** Whichever team wins a coin toss kicks off and begins play. The ball returns to the center spot after a goal and at the start of the second half. All oppos-

ing players must be in their own half at kick-off—at least 10 yards (9.15 m) from the ball.

9. **In and out.** The ball is out of play when it crosses any of the touchlines or goal lines, or if play has been stopped by the referee. It is in play at all other times.

10. **Scoring.** The whole ball has to pass over the goal line. If a member of the defending team knocks it in by accident, it is an "own goal" and still valid. Whoever scores the most goals wins.

11. **Offside.** The offside rule is designed to stop players from hanging around the goal of their opponents, waiting for a long ball to come to them. A player is given offside if the ball is passed to him while he is nearer to the goal than the ball and the second-last defender. Note that players are allowed to sit on the goal line if they want, but the ball cannot come to them without offside being called by the referee. An "offside trap" is when defenders deliberately move up the field to leave a forward player in a position where he cannot take the ball without being called offside. It is not an offside offense if the ball comes to a player from a throw-in, a goal kick, or a corner kick.

12. **Fouls.** Direct and indirect free kicks can be given to the opposing team if the referee judges a foul has

been committed. The kick is taken from where the foul occurred, so if it is close to the opponent's goal, the game can easily hinge on the outcome. Fouls can range from touching the ball with the hands to kicking an opponent. In addition, the player can be cautioned or sent off depending on the offense.

13. **Free kicks.** Direct free kicks can be a shot at goal if the spot is close enough, so are given for more serious fouls. The ball is stationary when kicked. Opposing players are not allowed closer than 10 yards (9.15 m), which has come to mean in practice that the opposing team puts a wall of players 10 yards from the spot to obscure the kicker's vision.

Indirect free kicks cannot be directly at goal, but must first be passed to another player.

14. **Penalties.** These are awarded for the same offenses as direct free kicks—if the offense happens inside the penalty area of the opposing team. This is to prevent what are known as "professional fouls," where an attacker is brought down deliberately to stop him from scoring.

The goalkeeper must remain on his goal line between the posts until the ball has been kicked. Other players must be outside the penalty area and at least 10 yards from the penalty spot—that's why there's an arc on the penalty area.

The penalty must be a single strike at the goal. As

long as it goes in, it can hit the posts and/or goal-keeper as well. In the normal run of play, a penalty kick that rebounds off the keeper is back in play and can be struck again. In a penalty shootout, this does not apply, and there is only one chance to score.

15. **Throw-ins.** A player must face toward the field and have both feet on the ground, on or behind the touchline. Both hands must be used, and the ball must be delivered from behind the head. The thrower must pass the ball to another player before he can touch it again.

16. **Goal kicks.** These are given when the opposing team kicks the ball over the opposing goal line, after a missed shot at goal, for example. The goal kick is taken from anywhere within the goal area, and the ball must pass out of the penalty area before another player can touch it.

17. **Corner kicks.** These are given when a member of the defending team knocks the ball over his own goal line.

The goalkeeper may do this in the process of saving a goal, for example, or a defender may do it deliberately to prevent a shot reaching goal. Many goals are scored from corner kicks.

Defending players must remain at least 10 yards (9.15 m) from the ball until it is kicked. In practice, they group themselves around the goalmouth. Defenders work hard to prevent attackers from finding a free space. Attackers work to drop their marking defender, get the ball as it comes in, and either head or

kick it into the goal. A goalkeeper is hard-pressed during corners. Visibility is reduced due to the number of people involved, and the ball can come from almost anywhere with very little time to react.

OTHER POINTS OF INTEREST

The goalkeeper is the only player who is allowed to use his hands. However, apart from the lower arms and hands, any other part of the body can be used to help control the ball.

If the game must be played to a conclusion (in a World Cup, for example), extra time can be given. There are various forms of this, but it usually involves two halves of fifteen minutes each. If the scores are still tied at the end of extra time, a penalty shootout is used to decide the winner. Five prearranged players take it in turns to shoot at the goal. If the scores are *still* tied, it goes to sudden-death penalties, one after the other until a winner is found.

One advantage that soccer has over some other sports is the fact that if you have a wall, you can practice it forever. Most other games really need someone else. There are many ball skills that must be experienced to be learned. It's all very well reading that you can bend the ball from right to left in the air by striking the bottom half of the right side of the ball with the inside of your foot, or left to right by using the outside of your foot on

the bottom half of the left side of the ball. Realistically though, to make it work, you'll have to spend many, many hours practicing. This is true of any sport—and for that matter any skill of any kind. If you want to be good at something, do it regularly. It's an old, old phrase, but "practice makes perfect" is as true today as it was hundreds of years ago. Natural-born skill is fine, but it will only take you so far against someone who has practiced every day at something he loves.

BASEBALL'S "MOST VALUABLE PLAYERS"

—※—

B ASEBALL IS STILL America's national pastime and each spring, hundreds of thousands of people swarm to parks and stadiums to watch their favorite teams duke it out on the field.

The first mention of baseball in the United States was published in a city statute in Pittsfield, Massachusetts, in 1791. The bylaw prohibited the playing of baseball within 80 yards of the local meetinghouse. Professional baseball began to be played in the 1860s. Ten years later, newspapers began calling the sport "The National Pastime."

The first major league was the National Association, established in 1871. It lasted only four years, and shut down in 1875. The National League was founded a year later, in 1876. There were other major leagues that failed, but the National League still exists, as does the American League, which began in 1901. The American League began as the Western League, a minor league.

The Major League Baseball season begins in April (or late March) and runs into October. The season includes the regular season, the play-offs, and the World Series. Every team wants to win the World Series, the championship series of the major leagues. The championships are played between the American League and National

League champions in a best-of-seven play-off. The New York Yankees have the most World Series titles: as of this writing, they have won twenty-six championships.

For an individual player, the biggest honor in baseball is to be named Most Valuable Player. Each year, the Baseball Writers Association of America determines who the MVPs are. We list them here for you, going back to 1958.

MOST VALUABLE PLAYERS

AMERICAN LEAGUE				NATIONAL LEAGUE			
Year	Player	Team	Pos.	Year	Player	Team	Pos.
2007	Alex Rodriguez	New York	3B	2007	Jimmy Rollins	Philadelphia	SS
2006	Justin Morneau	Minnesota	1B	2006	Ryan Howard	Philadelphia	1B
2005	Alex Rodriguez	New York	3B	2005	Albert Pujols	St. Louis	1B
2004	Vladimir Guerrero	Anaheim	RF	2004	Barry Bonds	San Fran	LF
2003	Alex Rodriguez	Texas	SS	2003	Barry Bonds	San Fran	LF
2002	Miguel Tejada	Oakland	SS	2002	Barry Bonds	San Fran	LF
2001	Ichiro Suzuki	Seattle	RF	2001	Barry Bonds	San Fran	LF
2000	Jason Giambi	Oakland	1B	2000	Jeff Kent	San Fran	2B
1999	Ivan Rodriguez	Texas	C	1999	Chipper Jones	Atlanta	3B
						(Continued)	

AMERICAN LEAGUE				NATIONAL LEAGUE			
Year	Player	Team	Pos.	Year	Player	Team	Pos.
1998	Juan Gonzalez	Texas	OF	1998	Sammy Sosa	Chicago	OF
1997	Ken Griffey Jr.	Seattle	OF	1997	Larry Walker	Colorado	OF
1996	Juan Gonzalez	Texas	OF	1996	Ken Caminiti	San Diego	3B
1995	Mo Vaughn	Boston	1B	1995	Barry Larkin	Cincinnati	SS
1994	Frank Thomas	Chicago	1B	1994	Jeff Bagwell	Houston	1B
1993	Frank Thomas	Chicago	1B	1993	Barry Bonds	San Fran	OF
1992	Dennis Eckersley	Oakland	P	1992	Barry Bonds	Pittsburgh	OF
1991	Cal Ripken Jr.	Baltimore	SS	1991	Terry Pendleton	Atlanta	3B
1990	Rickey Henderson	Oakland	OF	1990	Barry Bonds	Pittsburgh	OF
1989	Robin Yount	Milwaukee	OF	1989	Kevin Mitchell	San Fran	OF
1988	Jose Canseco	Oakland	OF	1988	Kirk Gibson	Los Angeles	OF
1987	George Bell	Toronto	OF	1987	Andre Dawson	Chicago	OF
1986	Roger Clemens	Boston	P	1986	Mike Schmidt	Philadelphia	3B
1985	Don Mattingly	New York	1B	1985	Willie McGee	St. Louis	OF

(Continued)

AMERICAN LEAGUE				NATIONAL LEAGUE			
Year	Player	Team	Pos.	Year	Player	Team	Pos.
1984	Willie Hernandez	Detroit	P	1984	Ryne Sandberg	Chicago	2B
1983	Cal Ripken Jr.	Baltimore	SS	1983	Dale Murphy	Atlanta	OF
1982	Robin Yount	Milwaukee	SS	1982	Dale Murphy	Atlanta	OF
1981	Rollie Fingers	Milwaukee	P	1981	Mike Schmidt	Philadelphia	3B
1980	George Brett	Kansas City	3B	1980	Mike Schmidt	Philadelphia	OF
1979	Don Baylor	California	OF	1979	Keith Hernandez	St. Louis	1B
					Willie Stargell	Pittsburgh	1B
1978	Jim Rice	Boston	OF	1978	Dave Parker	Pittsburgh	OF
1977	Rod Carew	Minnesota	1B	1977	George Foster	Cincinnati	OF
1976	Thurman Munson	New York	C	1976	Joe Morgan	Cincinnati	2B
1975	Fred Lynn	Boston	OF	1975	Joe Morgan	Cincinnati	2B
1974	Jeff Burroughs	Texas	OF	1974	Steve Garvey	Los Angeles	1B
1973	Reggie Jackson	Oakland	OF	1973	Pete Rose	Cincinnati	OF
1972	Richie Allen	Chicago	1B	1972	Johnny Bench	Cincinnati	C
1971	Vida Blue	Oakland	P	1971	Joe Torre	St. Louis	3B

(Continued)

BASEBALL'S "MOST VALUABLE PLAYERS"

AMERICAN LEAGUE				NATIONAL LEAGUE			
Year	Player	Team	Pos.	Year	Player	Team	Pos.
1970	Boog Powell	Baltimore	1B	1970	Johnny Bench	Cincinnati	C
1969	Harmon Killebrew	Minnesota	1B/3B	1969	Willie McCovey	San Fran	1B
1968	Denny McLain	Detroit	P	1968	Bob Gibson	St. Louis	P
1967	Carl Yastrzemski	Boston	OF	1967	Orlando Cepeda	St. Louis	1B
1966	Frank Robinson	Baltimore	OF	1966	Roberto Clemente	Pittsburgh	OF
1965	Zoilo Versalles	Minnesota	SS	1965	Willie Mays	San Fran	OF
1964	Brooks Robinson	Baltimore	3B	1964	Ken Boyer	St. Louis	3B
1963	Elston Howard	New York	C	1963	Sandy Koufax	Los Angeles	P
1962	Mickey Mantle	New York	OF	1962	Maury Wills	Los Angeles	SS
1961	Roger Maris	New York	OF	1961	Frank Robinson	Cincinnati	OF
1960	Roger Maris	New York	OF	1960	Dick Groat	Pittsburgh	SS
1959	Nellie Fax	Chicago	2B	1959	Ernie Banks	Chicago	SS
1958	Jackie Jensen	Boston	OF	1958	Ernie Banks	Chicago	SS

MARBLING PAPER

I F YOU'VE EVER wondered how the marbled paper inside the covers of old books is created, here it is. It is a surprisingly simple process, but the results can be very impressive. Once you have the inks, there are all sorts of possibilities, like birthday wrapping paper or your own greeting cards.

You will need

- Marbling ink—available from any craft or hobby shop and some large stationers.
- A flat-bottomed tray—a cookie sheet for example.
- Paper for printing and newspaper ready to lay out the wet sheets.
- A small paintbrush, toothpick, comb, or feather to swirl ink.

At about $4 a jar, marbling ink is expensive, but you need only a tiny amount for each sheet, so inks last for years. We began with red, blue, and gold.

We used regular 8.5"×11" paper, but almost any blank paper will do. You could do this in the bath, but remember to clean it later or you will have a blue father or mother the following morning. The paper must not have a shiny surface, or the inks won't penetrate.

1. Fill the tray with water to the depth of about an inch (25 mm). It is not necessary to be exact.
2. Using the small brush, or a dropper, touch the first color to the water surface. It will spread immediately in widening circles.
3. Speckle the water with circles of your colors, then when you are satisfied, swirl the colors with a toothpick, a comb, or a feather. Anything with a point will do for the first attempt.
4. When the pattern is ready, place the sheet of paper face down onto it and wait for sixty seconds. That is long enough for printer paper, though times may vary with different types.
5. Take hold of one end of the paper and pull it upward out of the liquid. There really isn't any way to do this incorrectly, as far as we could tell—it really is easy. Wash your paper under the tap to get rid of excess ink. Place the wet sheet on newspaper and leave to dry.

If you have access to a color copier or printer, you could make a copy with certain sections blanked off. The spaces could then be used for invitation details, or the title of a diary or story—perhaps an old-fashioned Victorian ghost story, with an old-fashioned marble-paper cover. Dark green, gold, and black is a great combination.

RIDDLES

———✶———

RIDDLES ARE FIENDISH puzzles, usually set in words. In ancient times, King Solomon used them to test the wits of friends and enemies—and had his own tested in the same way by the queen of Sheba. In the Bible, Samson saw a beehive in the body of a dead lion. He ate the meat and honey and posed this riddle to his enemies: "Out of the eater came meat. Out of the strong came forth sweetness."

History is full of interesting examples of the form. According to the Greek historian Plutarch, Homer apparently died from frustration when he could not solve the riddle of the fishermen of Ios (see #2).

Another Greek example was a physical puzzle. The Gordian knot was a huge nest of twisted bark in a great ball, with no ends showing. An oracle had predicted that the man who loosed the knot would rule all of Asia. When Alexander the Great came upon the shrine that housed the knot, he solved the problem by taking his sword and cutting it in half, fulfilling the prophecy.

Perhaps the most famous of all is the Riddle of the Sphinx. In Greek mythology, the Sphinx was a huge lion with the head of a ram, falcon, or a man. When travelers came upon the beast, it would ask its riddle and if they could not answer, it would kill them.

All the answers are below, but take a little time to consider the riddles first.

1. The Riddle of the Sphinx

 "What goes on four legs in the morning, two legs in the afternoon, and three legs in the evening?"

 Oedipus was the Greek hero who solved the riddle, and the Sphinx destroyed itself in rage.

2. The riddle put to Homer by the fishermen of Ios

 "What we caught we threw away; what we didn't catch, we kept."

3. An anonymous riddle of ancient Greece

 "I am the black child of a white father;
 A wingless bird, flying even to the clouds of heaven. I give birth to tears of mourning in pupils that meet me, and at once on my birth I am dissolved into air."

4. Around a hundred Anglo-Saxon riddles survive. Some come from *Beowulf*, which was written in the Middle Ages (AD 500–1500). They were not meant to be asked and answered quickly but mulled over. Here are three good ones.

(i) "The creature ate its words. It seemed to me strangely weird when I heard this wonder: that it devoured human speech. A thief in the darkness, gloriously mouthed the source of knowledge. But the thief was not wiser, for all the words in his mouth."

(ii) "When I am alive I do not speak.
Anyone who wants to takes me captive and cuts off my head.
They bite my bare body
I do no harm to anyone unless they cut me first.
Then I soon make them cry."

(iii)"I am all on my own,
Wounded by iron weapons and scarred by swords.
I often see battle.
I am tired of fighting.
I do not expect to be allowed to retire from warfare
Before I am completely done for.
At the wall of the city, I am knocked about
And bitten again and again.
Hard-edged things made by the blacksmith's hammer attack me.
Each time I wait for something worse.
I have never been able to find a doctor who could make me better

 Or give me medicine made from herbs.
 Instead the sword gashes all over me grow bigger
 day and night."

5. This one is much later, written by the author of *Gulliver's Travels*, Jonathan Swift (1667–1745).

 "Begotten, and Born, and dying with Noise,
 The Terror of Women, and Pleasure of Boys,
 Like the Fiction of Poets concerning the Wind,
 I'm chiefly unruly, when strongest confin'd.
 For Silver and Gold I don't trouble my Head,
 But all I delight in is Pieces of Lead;
 Except when I trade with a Ship or a Town,
 Why then I make pieces of Iron go down.
 One Property more I would have you remark,
 No Lady was ever more fond of a Spark;
 The Moment I get one my Soul's all a-fire,
 And I roar out my Joy, and in Transport expire."

6. Later still, is this one by William Davidson (1781–1858)

 "My sides are firmly lac'd about,
 Yet nothing is within;
 You'll think my head is strange indeed,
 Being nothing else but skin."

7. As a final example, here is a riddle said to have been written by Albert Einstein in the late nineteenth century.

It is extremely complex, but there are no tricks. Cold logic will solve it, though Einstein apparently estimated that only 2 percent of humanity would have the intelligence to find the answer. You might like to try it on a math teacher.

a. In a street there are five houses, painted five different colors.
b. In each house lives a person of different nationality.
c. These five homeowners each drink a different kind of beverage, smoke a different brand of cigar, and keep a different pet.

The question is: Who owns the fish?

Clues:

1. The Brit lives in a Red house.
2. The Swede keeps dogs as pets.
3. The Dane drinks tea.
4. The Green house is next to, and on the left of the White house.
5. The owner of the Green house drinks coffee.
6. The person who smokes Pall Mall rears birds.
7. The owner of the Yellow house smokes Dunhill.
8. The man living in the center house drinks milk.
9. The Norwegian lives in the first house.
10. The man who smokes Blends lives next to the one who keeps cats.

11. The man who keeps horses lives next to the man who smokes Dunhill.
12. The man who smokes Blue Master drinks beer.
13. The German smokes Prince.
14. The Norwegian lives next to the Blue house.
15. The man who smokes Blends has a neighbor who drinks water.

Answers:

1. A man—who crawls as a baby, walks as a man and then uses a stick as an old fellow.
2. The fishermen had lice.
3. Smoke.
4. (i) A bookworm, or a moth (ii) An onion (iii) A shield.
5. A cannon.
6. A drum.
7. You're going to need to draw a grid for this one (see next page). It is a process of elimination and slowly building a picture of what we know. For example, the Brit lives in a red house and the owner of the yellow house smokes Dunhill—so we know the Brit cannot smoke Dunhill. As you can see from the grid, it is the German who owns the fish.

	House 1	House 2	House 3	House 4	House 5
Color	Yellow	Blue	Red	Green	White
Nationality	Norwegian	Dane	Brit	German	Swede
Drink	Water	Tea	Milk	Coffee	Beer
Smokes	Dunhill	Blends	Pall Mall	Prince	Blue Master
Pet	Cats	Horses	Birds	Fish	Dogs

UNDERSTANDING GRAMMAR—PART ONE

———✲———

IT'S STRANGE HOW satisfying it can be to know right from wrong. Grammar is all about rules and structure. It is *always* "between you and me," for example. If you hear someone say "between you and I," it isn't a matter of opinion, they're just wrong.

The grammar of English is more complex than can be contained here, but a skeleton of basics is well within our reach. You wouldn't use a chisel without knowing how to hold it. In the same way, you really should know the sharp end from the blunt one in everything else you use—including your language. The English language is spoken by more people on earth than any other, after all.

The first thing to know is that there are only nine kinds of words. Nine.

➣ Nouns ➣

1. **Nouns** are the names of things. There are three kinds. Proper nouns have capital letters: "New York." Abstract nouns are the things that exist but you can't touch: "courage," "loyalty," "cruelty," "kindness." Common nouns are the words for everything else: "chair," "eyes," "dog," "car," and so on.

⤚ **Verbs** ⤛

2. **Verbs** are words for action or change: "to become," "to wash," "to dissect," "to eat," and so on. There are six parts to each verb, known as first person singular, second person singular, third person singular, first person plural, second person plural, and third person plural.

Most verbs follow this simple pattern.

To deliver

First person singular:	*I deliver*
Second person singular:	*You deliver*
Third person singular:	*He/She/It delivers*—note the *s*
First person plural:	*We deliver*
Second person plural:	*You deliver*
Third person plural:	*They deliver*

Irregular verbs like "to be" and "to have" are not as . . . well, not as regular. They must be learned.

To be	**To have**
I am	I have
You are	You have
He/She/It is	He/She/It has
We are	We have

To be	To have
You are	You have
They are	They have

Note that the second person "you" is the same in the singular and plural. In older forms of English, you would have used "thou" as second person singular. In modern English it makes no difference whether you are addressing one man or a thousand, you could still begin as follows: "You are responsible for your behavior."

∽ Adverbs ∾

3. **Adverbs** are the words that modify verbs, adjectives, and other adverbs. They are important as there is a huge difference between "smiling nastily" and "smiling cheerfully." Clearly the verb is not enough on its own.

Most adverbs end in "-ly," as with the examples above.

If you say, "I'll go to the store tomorrow," however, "tomorrow" is an adverb, because it adds detail to that verb "go." Words like "soon" and "often" also fall into this category. As a group, these are sometimes known as "adverbs of time."

As mentioned above, an adverb can also add detail to an adjective. "It is really big" uses "really" as an adverb. "It is very small" uses "very" as an adverb. He walked "extremely quietly" uses "extremely" as an ad-

verb for an adverb! This is not rocket science. Take it slowly and learn it all bit by bit.

⤙ Adjectives ⤚

4. **Adjectives** are words that modify nouns. In "the enormous snake," "enormous" is the adjective. More than one can be used together, thus: "the small, green snake." Note the comma between the two adjectives. Putting a comma between adjectives is usually correct.

 As a general rule, adjectives come before the noun. However, as always with English, rules have many exceptions: "That snail is *slimy*!" is one example.

⤙ Pronouns ⤚

5. **Pronouns** are words that replace nouns in a sentence. It would sound clumsy to say "John looked in John's pockets." Instead, we say "John looked in *his* pockets." "his" is a pronoun.

 Here are some examples: *I, you, he, she, we, they—me, you, him, her, us, them—my, your, his, her, our, their.*

 "One" is also used in place of "people in general," as in the following sentence: "One should always invest in reliable stocks." The informal form of this is "you," but it does sometimes lead to confusion, which keeps this unusual use of "one" alive. The British Queen also

uses the "we" form in place of "I" during formal announcements.

⟨ Conjunction ⟩

6. A **conjunction** is a word that joins parts of a sentence together. "I tied the knot and hoped for the best." Tying the knot is a separate action from hoping for the best, joined by the word "and." Conjunctions can also join adjectives, "short and snappy," or adverbs "slowly but surely."

 Examples: *and, so, but, or, if, although, though, because, since, when, as, while, nor.*

 The general rule is: "A sentence does not begin with a conjunction." Yes, you will find examples where sentences do begin with a conjunction. Professional writers do break this rule, but you should know it to break it—and even then do it carefully.

 The examples above are fairly straightforward. It does get a little trickier when a conjunction is used to introduce a subordinate clause. (Clauses are covered in Understanding Grammar—Part Two.)

 "Although he was my only friend, I hated him." (Although.)

 "As I'm here, I'll have a drink." (As.)

 In these two examples, the sentences have been rearranged to change the emphasis. It would have been clearer, perhaps, to write, "I'll have a drink as I'm

here," or "I hated him although he was my only friend." It's easier to see "although" and "as" are being used as joining words in that way, but many sentences begin with a subordinate clause.

⤳ Articles ⤳

7. **Articles** are perhaps the easiest to remember: "a," "an," and "the." That's it.

"A/an" is the **indefinite** article. Used when an object is unknown. "A dog is in my garden." "An elephant is sitting on my father."

"The" is the **definite** article. "The dog is in the garden" can refer to a particular dog. "The elephant is sitting on my father" can mean only one elephant—one we already know, a family pet, perhaps.

"An" is still sometimes used for words that begin with a clearly sounded "h": "an historical battle," "an horrendous evil," and so on. It is seen as old-fashioned, though, and using "a" is becoming more acceptable.

⤳ Prepositions ⤳

8. **Prepositions** are words that mark the position or relationship of one thing with respect to another. Examples: *in, under, over, between, before, behind, through, above, for, with, at,* and *from.*

"He fell from grace" demonstrates "from" as a preposition. Another example is "He lived *before* Caesar," or "I stood *with* Caesar."

The general rule for prepositions is: "Don't end a sentence with a preposition."

It is not correct to say "This is my son, whom I am most pleased with." It should be "This is my son, with whom I am most pleased."

⤚ Interjections ⤜

9. This is another of the easier types. **Interjections** are simple sounds used to express an inward feeling such as sorrow, surprise, pain, or anger. This can be a wide group, as almost anything can be said in this way. Obvious examples are: *Oh! What? Hell! Eh? Goodness gracious!*

 Note the last one—interjections don't have to be a single word. It could be a whole phrase like "Oh, for Pete's sake!" or a complex oath. They tend to stand on their own and often have exclamation marks following them.

THAT IS ALL NINE.

Bearing in mind that English has more words than any other language on earth, it is quite impressive that there are only nine kinds. The first part of grammar is to learn those nine well and be able to identify them in a sentence. If you have, you should be able to name each of the eight

kinds of words used in the following sentences. If it helps, we didn't use a conjunction.

"No! I saw the old wolf biting viciously at his leg."
(Answer: "No!"—interjection, "I"—pronoun, "saw"—verb, "the"—definite article, "old"—adjective, "wolf"—common noun, "biting"—verb, "viciously"—adverb, "at"—preposition, "his"—pronoun, "leg"—common noun. Eight different types.)

OPTICAL ILLUSIONS

OPTICAL ILLUSIONS ARE something that tricks the eye or the mind. As well as being great fun, some of them give an insight into how the eye works. Here are some of the different types that will show whether you really can believe your eyes—or not.

Stare at the dot in the picture for twenty seconds. Now look at a white piece of paper. For an instant, you will see a famous lady, painted by Leonardo da Vinci.

This works because your retina (the surface at the back of the eyeball) retains images, especially ones with high contrast or brightness. Effectively, they're burned in, but it's only temporary. That's why staring at a light-bulb will result in a green light in your vision even after you have looked away.

Your retina has a layer of light receptive cells, but it only covers 72 percent of the surface. The rest is the optic nerve that sends the signals to your brain. As a result, both your eyes contain a "blind spot" that can be revealed.

Close your left eye and move the page so that the cross is in front of your right eye. Stare at the X and hold the book at arm's length, moving it slowly toward you. At some point, the dot will vanish as it moves into the blind spot.

Your brain works by learning patterns, a constantly

evolving mass of experience that works as a shortcut when you see a new object. Because of this, it can be fooled. Are you looking at circles within circles here, or a spiral? Your brain will see clues that make it believe it's a spiral, but something doesn't quite fit.

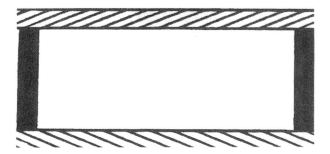

Are the two striped bars above closer on the right than the left? Measure and find out.

Sometimes, your brain just can't decide what it is looking at. In the image below, is this a block with a bit cut out or with a piece stuck on?

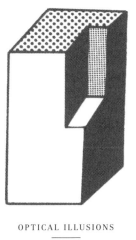

Here's one that involves fooling the brain into seeing movement.

As well as these, there are thousands of well-known optical illusions. They are interesting in part because they challenge our belief that what we see is real.

Our bodies are wonderfully complex structures that carry our brains, held in bone, and balanced on a spine. From that viewpoint, we judge the world through senses that are not as reliable as we think.

The work of M. C. Escher is well worth a look if you want to stretch your brain a little.

GIRLS

—⁂—

YOU MAY ALREADY have noticed that girls are quite different from you. By this, we do not mean the physical differences, but more that they remain unimpressed by your mastery of a game involving wizards, or your understanding of Morse Code. Some will be impressed, of course, but as a general rule, girls do not get quite as excited by the use of urine as a secret ink as boys do.

We thought long and hard about what advice could possibly be suitable. It is an inescapable fact that boys spend a great deal of their lives thinking and dreaming about girls, so the subject should be mentioned here—as delicately as possible.

ADVICE ABOUT GIRLS

1. It is important to listen. Human beings are often very self-centered and like to talk about themselves. In addition, it's an easy subject if someone is nervous. It is good advice to listen closely—unless she has also been given this advice, in which case an uneasy silence could develop, like two owls sitting together.

2. Be careful with humor. It is very common for boys to try to impress girls with a string of jokes, each one

more desperate than the last. One joke, perhaps, and then a long silence while she talks about herself . . .

3. When you are older, flowers really do work—women love them. When you are young, however, there is a ghastly sense of being awkward rather than romantic, and she will guess your mother bought them.

4. Valentine's Day cards. Do not put your name on them. The whole point is the excitement a girl feels, wondering who finds her attractive. If it says "From Brian" on it, the magic isn't really there. This is actually quite a nice thing to do to someone you don't think will get a card. If you do this, it is even more important that you never say, "I sent you one because I thought you wouldn't get any." Keep the cards simple. You do not want one with frills of any kind.

5. Avoid being vulgar. Excitable bouts of windbreaking will not endear you to a girl, just to pick one example.

6. Play a sport of some kind. It doesn't matter what it is, as long as it replaces the corpselike pallor of the computer programmer with a ruddy glow. Honestly, this is more important than you know.

7. If you see a girl in need of help—unable to lift something, for example—do not taunt her. Approach the object and greet her with a cheerful smile, while sur-

reptitiously testing the weight of the object. If you find you can lift it, go ahead. If you can't, try sitting on it and engaging her in conversation.

8. Finally, make sure you are well scrubbed, your nails are clean, and your hair is washed. Remember that girls are as nervous around you as you are around them, if you can imagine such a thing. They think and act somewhat different, but without them, life would be one long football locker room. Treat them with respect.

LATIN PHRASES EVERY BOY SHOULD KNOW

―――=◦＊◦=―――

THERE ARE HUNDREDS of thousands of Latin roots in English. If that wasn't enough, some Latin words have become so common they are often believed to be English! "Agenda" (things to be done), "alter ego" (other self), "exit" (he/she leaves), "verbatim" (word for word), and "video" (I see) fall into that group. There is satisfaction in understanding your own language—and that includes its origins.

Latin phrases crop up in conversation as well as in the law courts. It is still the gold standard of education, but be warned—showing off is not a suitable reason for learning this list.

The precision of Latin can be a pleasure, but the main reason for this chapter is cultural. If you know English, you should know a little Latin. What follows can only ever be a small sample of the whole.

Learn one a day, perhaps. After each phrase, you'll find a homemade phonetic pronunciation guide. Stressed syllables are in capitals (SCIS-sors, DI-no-saur.) For some, you'll find an example of it being used.

1. **Ad hoc** (ad hok). Literally "to this." Improvised or made up. "I wrote an ad hoc poem."
2. **Ad hominem** (ad HOM-in-em). This is a below-the-belt,

personal attack, rather than a reasoned response to an argument.

3. **Ad infinitum** (ad in-fin-EYE-tum). To infinity—carried on endlessly. "And so on and so on, ad infinitum. . . ."

4. **Anno Domini** (AN-no DOM-in-eye). In the year of our Lord. Example: "This is the year of our Lord, 1492—when Columbus sailed the ocean blue."

5. **Ante meridiem** (AN-tay Mer-ID-ee-em). Before noon— 4 a.m., for instance.

6. **Aqua vitae** (AK-wa VIT-eye). Water of life. Most often used to refer to whiskey or brandy.

7. **Audio** (AW-di-o). I hear. Romans would probably have pronounced this like Audi (OW-di) cars.

8. **Bona fides** (BONE-uh FIDE-eez). Bona fides are credentials establishing good faith or honesty. Technically it is nominative singular, but it is usually heard with a plural verb these days, because it ends in *s*.

9. **Carpe diem** (CAR-pay DEE-em). Seize the day, or use your time.

10. **Cave canem** (CAV-ay CAN-em). Beware of the dog. Found preserved in a mosaic floor in Pompeii, to name one place.

11. **Circa** (SUR-ca). Around, approximately. Julius Caesar was born circa 100 BC.

12. **Cogito, ergo sum** (COG-it-o ER-go sum). "I think, therefore I am"—a famous conclusion from René Descartes, the French philosopher. He considered the statement to be the only defensible proof of existence. All else could be fantasy.

13. **Curriculum vitae** (cur-IC-you-lum VEET-eye). The course of life, or school and work history. Usually abbreviated to CV.

14. **Deus ex machina** (DAY-us ex MAK-in-a). Literally, a god out of a machine, as when Greek playwrights would have Zeus lowered on wires to solve story problems. It has come to mean poor storytelling, where some outside force makes it all end well.

15. **Dulce et decorum est pro patria mori** (DOOL-chay et de-COR-um est pro pat-ri-ya MORE-ee). "It is sweet and fitting to die for your country." A line from Horace. Later used ironically by Wilfred Owen in a World War I poem.

16. **Ergo** (UR-go). Therefore.

17. **Exempli gratia** (ex-EM-pli GRAH-ti-ya). For (the sake of) example, usually abbreviated to "e.g."

18. **Fiat lux!** (FEE-at lux). Let there be light!

19. **Habeas corpus** (HABE-e-as CORP-us). Literally "You must have the body." This has come to mean that a person cannot be held without trial; the "body" must be brought before a court.

20. **Iacta alea est** (YACT-a ali-ya est). The die is cast. Julius Caesar said this on the Rubicon river, when he was deciding to cross it. He meant "It's done. The decision is made."

21. **In camera** (in CAM-e-ra). In secret, not in the open. "The meeting was held in camera."

22. **In flagrante delicto** (in flag-RANT-ay de-LICT-o). In "flaming crime," caught red-handed, or in the act.

23. **Ipso facto** (IP-so FACT-o). By the fact itself. "I have barred my house to you. Ipso facto, you are not coming in."
24. **Magna cum laude** (MAG-na coom LOUD-ay). With great praise and honor. "He graduated magna cum laude."
25. **Modus operandi** (MODE-us op-er-AND-ee). Method of operation, a person's professional style of habits.
26. **Non compos mentis** (non COM-pos MEN-tis). Not of sound mind. Crazy.
27. **Non sequitur** (non SEK-wit-er). Does not follow, a broken argument. "He never takes a bath. He must prefer cats to dogs."
28. **Nota bene** (NO-ta BEN-ay). Note well. Usually abbreviated to "n.b." Note that "Id est" is also very common and means "that is." "Id est" is usually abbreviated to "i.e."
29. **Paterfamilias** (PAT-er-fam-IL-i-as). Father of the family, paternal figure.
30. **Persona non grata** (Per-SONE-a non GRAT-a). An unwelcome person.
31. **Post meridiem** (POST me-RID-ee-em). After noon, usually abbreviated to "p.m."
32. **Post mortem** (post MOR-tem). After death. Usually taken to mean investigative surgery to determine cause of death.
33. **Postscriptum** (post-SCRIP-tum). Literally "thing having been written afterward," usually abbreviated to "p.s."

34. **Quis custodiet ipsos custodes?** (kwis cus-TOAD-ee-yet IP-soss cus-TOAD-ez). Who guards the guards?

35. **Quod erat demonstrandum** (kwod e-rat dem-on-STRAN-dum). Which was to be demonstrated. Usually written as QED at the end of arguments.

36. **Quo vadis?** (kwo VAD-is). Where are you going?

37. **Requiescat in pace** (rek-wi-ES-cat in pa-chay). "May he or she rest in peace," usually abbreviated to RIP.

38. **Semper fidelis** (SEMP-er fid-EL-is). Always faithful. The motto of the U.S. Marine Corps. The motto of the state of Kansas is "Ad Astra Per Aspera"—through difficulties to the stars. Many of the states have Latin mottoes, which are found on the states' flags.

39. **Senatus Populusque Romanus** (sen-AH-tus pop-yool-US-kway rome-AHN-us). The senate and the people of Rome. Imperial legions carried SPQR on their banners. Oddly enough, it is still to be found on manhole covers in modern Rome.

40. **Status quo** (STATE-us kwo). "The state in which things are." The existing state of affairs. Example: "It is crucial to maintain the status quo."

41. **Stet** (stet). Let it stand. Leave it alone. Often used in manuscripts, to indicate that no editing change is necessary.

42. **Sub rosa** (sub ROSE-a). Under the rose, secret. From the custom of placing a rose over a doorframe to indicate what was said inside was not to be repeated.

43. **Tabula rasa** (TAB-yool-a RAH-sa). Literally a "scraped tablet." Blank slate. A state of innocence.

44. **Terra firma** (TER-a FIRM-a). Solid ground.
45. **Terra incognita** (TER-a in-cog-NIT-a). Land unknown. Used on old maps to show the bits as yet unexplored.
46. **Vade retro satana!** (VA-day RET-ro sa-TAHN-a). Get behind me, Satan! This is an order to crush desires or temptations to sin.
47. **Veni, vidi, vici** (WAYN-ee WEED-ee WEEK-ee). I came, I saw, I conquered. Said by Julius Caesar after he defeated a rebellion in Greece in one afternoon.
48. **Versus** (VER-sus). Against, usually abbreviated to "v." or "vs."
49. **Veto** (VEE-tow). I forbid. Another one so commonly used as to appear English.
50. **Vox populi** (vox POP-yool-ee). Voice of the people. Often abbreviated to a "Vox Pop"—a short interview on the street.

AND THE NUMBERS . . .

There are only seven kinds of Roman numerals. These are: I, V, X, L, C, D, and M (1, 5, 10, 50, 100, 500, and 1,000). From just those seven, all other numbers can be made. The only difficulty comes in recognizing that some numbers, like four and nine, are made by IV and IX—one less than five, one less than ten. This pattern is used all through Roman numerals, so nine hundred ninety-nine will be IM. That's it. Spend ten minutes on this page and then go and read any gravestone you wish.

I II III IV V VI VII VIII IX X **(1–10)**

XI XII XIII XIV XV XVI XVII XVIII XIX XX **(11–20)**

XXX **(30)** XL **(40)** L **(50)** LX **(60)** LXX **(70)**

LXXX **(80)** XC **(90)** C **(100)**

The year 1924, for example, would be represented as MDCCCCXXIV; the year 2008 is MMVIII.

FAMOUS BATTLES—PART ONE

For the most part, history springs from both noble and petty sources—from jealousy and murder as much as the dreams of great men and women. As well as being formed in new laws and sweeping cultural movements, history is made on the battlefield, with entire futures hanging on the outcome. You will find further study of these examples both enlightening and rewarding. Each is an extraordinary story in itself. Each had repercussions that helped to change the world.

1. THERMOPYLAE
480 BC

Darius the Great ruled the Persian lands known today as Iran and Iraq, pursuing an aggressive policy of expansion. He sent his heralds to Greek cities to demand submission. Many accepted, though Athens executed their herald and Sparta threw theirs down a well. War followed and Darius's ambitions came to an abrupt end when he was beaten at the Battle of Marathon in Greece. Although he planned another great invasion, his death prevented his return. It would fall to his son, Xerxes, to invade northern Greece with a vast army of more than 2 million in the spring of 480 BC.

The Persian fleet had already won control of the sea, and

COAST AT MIDDLE GATE OF THERMOPYLÆ IN 480.
1, 2, 3, mark the three positions of the defenders of the Pass.
Scale, 8″ to 1 mile.

the Greeks could not hold the north against such a vast host. Instead, they chose to defend the pass at Thermopylae in the south. Here, the way through the mountains was a tiny path only fourteen feet wide at its narrowest point. Thermopylae means "Hot Gates," named after thermal springs in the area.

The Spartan king, Leonidas, took his personal guard of 300 Spartans and about 7,000 other foot soldiers and archers to the pass. Of all the Greek leaders, he alone seemed to understand the desperate importance of resist-

ing the enemy horde. When he reached the pass, his men rebuilt an ancient wall, and 6,000 soldiers waited at the middle gate, the other 1,000 guarding a mountain trail above. They did not expect to survive, but Spartans were trained to scorn fear and hardship from a young age. They prided themselves on being elite warriors.

The Royal Guard was all fathers, allowed to attend the king only after they had contributed to the gene pool of Sparta. They revered courage above all else.

The Persian king sent scouts to investigate the pass. He was surprised to hear that the Spartans were limbering up and braiding their hair for battle. Unable to believe that such a small group would honestly wish to fight, he sent a warning to withdraw or be destroyed. They made him wait for four days without a reply. On the fifth day, the Persian army attacked.

From the beginning, the fighting was brutal in such a confined space. The Spartans and the other Greeks fought for three solid days, throwing the Persians back again and again. Xerxes was forced to send in his "Immortals"—his

best warriors. The Spartans proved the Immortals were poorly named by killing large numbers of them. Two of Xerxes's brothers were also killed in the fighting.

In the end, Leonidas was betrayed by a Greek traitor. The man went to Xerxes and told him about a mountain track leading around the pass at Thermopylae. Leonidas had guarded one track, but for those who knew the area, there were others. Xerxes sent more of his Immortals to the secret path, and they attacked at dawn. The other Greek soldiers were quickly routed, but Leonidas and the Spartans fought on.

When Leonidas finally fell, he had been cut off from the rest of the Spartans. A small group of the guard fought their way into the heaving mass, recovered his body, and carried him to where the others were surrounded, fighting all the way. The Persians simply could not break their defense, and finally Xerxes ordered them to be cut down with flight after flight of heavy arrows. He was so furious at the losses his army had suffered that he had Leonidas beheaded and his body nailed to a cross.

The Spartans went on to play a crucial part in the war against the Persians. Leonidas and his small guard had established an extraordinary reputation, and larger forces of Spartans struck terror into the Persians in later battles. They had seen what only 300 could do, and no one wanted to face 10,000 or 20,000. The Greeks won classic sea battles at Salamis and Eurymedon, destroying the Persian fleet. Over the next eight years, they beat the Persian host on land with battles at Plataea and My-

cale. They lost Athens twice to the enemy and saw it completely destroyed. Much of the war has been forgotten, but the battle at Thermopylae still inspires writers and readers today. When peace returned, the Spartans placed a stone lion at the Hot Gates to mark where Leonidas created a legend. The epitaph reads: "Go tell the Spartans, Stranger passing by, that here, obedient to their laws, we lie."

2. CANNAE
216 BC

When the Latini tribe consolidated their hold on southern Italy, they joined two settlements into a city named Rome on seven hills. In the centuries that followed, they continued to explore their lands and boundaries, north and south, eventually crossing into Sicily. There, they came face to face with an outpost of the ancient and sophisticated Carthaginian empire. It was a clash of force and culture that launched generations of bitter conflict in what have come to be known as the Punic Wars and the first real test of Rome.

The Battle of Cannae is famous in part because the Roman legions were utterly annihilated. This is a surprisingly uncommon event. History has many more examples of battles where the defeated enemy was allowed to leave the field, sometimes almost intact. Cannae was a complete destruction of an army in just one day. It was very nearly the death knell for Rome itself.

The Romans had actually won the First Punic War,

which lasted for twenty-three years (264–241 BC), but it had not been a crushing defeat for the Carthaginians. They had had a gifted general in Hamilcar Barca, who had brought southern Spain under the rule of Carthage. Yet it was his son Hannibal who would invade Italy from Spain, cross the Alps with elephants, and threaten the very gates of Rome. He commanded Carthaginian forces for the Second Punic War (218–201 BC).

Cannae is in southern Italy, near the heel of the "boot." Hannibal had come south the previous year, after destroying Roman armies of 40,000 and 25,000. Rome was in real danger.

The senate appointed a dictator, Fabius, who tried to wear Hannibal's forces down by cutting lines of supply. It was a successful policy, but unpopular in a vengeful city that wanted to see the enemy destroyed rather than just starved to death. New consuls were elected: Gaius Terentius Varro and Lucius Aemilius Paullus. The senate mustered an army of 80,000 infantry and 6,000 cavalry over which the consuls assumed joint leadership.

Hannibal's army had very few actual Carthaginians. When he entered what is today northern Italy, his forces consisted of 20,000 infantry (from Africa and Spain) and 6,000 cavalry. He recruited more from Gallic tribes in the north, but he was always outnumbered. In fact, the Romans had every possible advantage.

The two armies met on August 2, 216 BC. Hannibal and his army approached along the bank of a river, so he could not easily be flanked. He left 8,000 men to protect

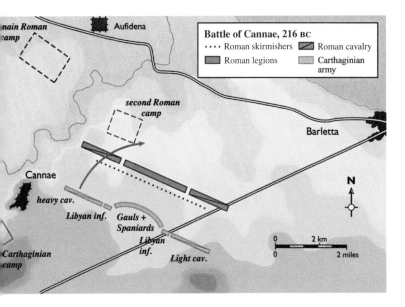

his camp. His cavalry was placed on both flanks, and his infantry took position in the center.

Varro was in command on the Roman side that day. He was not an imaginative leader and marched the Roman hammer straight at Hannibal's forces, attempting to smash them. Varro thought he had protected his wings from flanking maneuvers with his own cavalry. In fact, Hannibal's horsemen were far superior. They crushed one Roman flank almost immediately, *circling behind* them to destroy the other wing as well. They then wreaked havoc on Roman lines from behind.

Varro pressed on, however, his front line pushing the forces of Carthage farther and farther back, like a bow bending. Hannibal's front line had become completely concave, and Varro had no idea that it was part of the plan. The Roman force marched directly into the cup Hannibal had created for them. They believed they were winning.

Hannibal signaled for the wings to move—and the cup began to close. Hannibal's cavalry completed the boxing-in of the Roman legions behind. They were so compressed they could hardly move, and their numerical advantage had been completely canceled out. More than 60,000 died over the next few hours as they were butchered, unable to escape. Hannibal lost 6,000 men.

One result of this battle was that the Romans learned from it. Three years later they had more than 200,000 men under arms and had renewed the struggle. There were successes and disasters on both sides, and Rome teetered on the brink of destruction until the Romans appointed Publius Cornelius Scipio—known as Scipio Africanus. He had the vision and tactical skill to counter Hannibal. Even though Rome was near bankruptcy and Italy was starving, the fortunes of Rome began to turn.

3. JULIUS CAESAR'S INVASIONS OF BRITAIN
55–54 BC

Though neither invasion really came to anything, this has traditionally been the official starting point of recorded British history. In fact, Julius Caesar's own com-

mentary is the *only* written source for some of the information that has survived today, such as the names of tribes around the south coast of England.

The Romans' first landing was on the beaches near Deal in Kent, having sailed from Gaul (France). The Britons (meaning "painted ones" because they painted themselves blue) fought in the sea accompanied by huge dogs in order to prevent the landing. Caesar's reference to the dogs makes the English mastiff the oldest recorded breed. The Roman force fought their way onto dry land and made a truce with the local inhabitants. It is important to remember that Britain was practically off the edge of maps at this time. The existence of "foggy islands" or "tin islands" somewhere past Gaul was considered a myth in some places. Caesar was overstretched and spent only three weeks in Britain before heading back across the English Channel to Gaul.

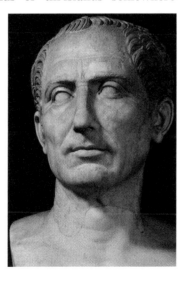

The second landing in 54 BC was much better organized. Caesar returned with a fleet of 800 ships, 5 legions, and 2,000 cavalry. As the Spanish Armada would discover fifteen hundred years later, the coast can be violent. A

storm smashed a large number of Caesar's ships, scattering many more.

Caesar marched north, destroying the tribes who had gathered under their war chief, Cassivellaunus of the Catuvellauni. Cassivellaunus was forced to sue for peace near modern St. Albans. Caesar accepted and returned to Gaul. Events such as the great Gaul rebellion under Vercingetorix, a civil war in Rome, falling in love with the Egyptian queen Cleopatra and, finally, assassination would prevent Caesar from ever returning. The Romans did not come back to Britain until AD 43, under Emperor Claudius.

4. HASTINGS
October 14, 1066

This is one of the most famous dates in English history—the last successful invasion of the island of Britain. After the Romans left, Britain was almost constantly invaded. First the Saxons proved bothersome, then just as everyone was settling down to being Anglo-Saxon, the Vikings arrived. The Danish king, Canute (sometimes written Cnut), created a small, stable empire early in the eleventh century, ruling England, Norway, Sweden, and Denmark. He had taken the English throne from Ethelred the Unready but after Canute's death, his feckless sons lost it back to Ethelred's son Edward, known as the Confessor for his piety. He named Harold Godwinson as his heir, crowned King Harold in January 1066—the last Anglo-Saxon king before the Normans arrived and spoiled it for everyone.

In fact, William of Normandy had probably been named heir by Edward the Confessor as far back as 1051. William had also extracted a promise from Harold Godwinson to support that claim when Harold was shipwrecked off Normandy in 1064. In that sense, William's 1066 landing was to protect his rightful throne, though that isn't the usual view. We don't know the exact size of his army, and estimates vary enormously. It was probably around 12,000 cavalry and 20,000 infantry.

In September, Harold was busy repulsing Norwegian invasions. The Norwegians had promised Harold's brother Tostig an earldom for his aid. Harold marched north from London to relieve York from a Norse army. He met them at Stamford Bridge on September 25, fighting for many hours. Of the 300 ships the Norwegians had brought over, only 24 were needed for the survivors. Tostig was killed. Stamford Bridge resulted in heavy casualties among Harold's best soldiers, which was to prove of vital importance to the later battle at Hastings.

On September 28, William of Normandy landed on the Sussex coast. Harold heard of the landing by October 2 and immediately marched 200 miles south; his army covered the distance in less than five days. That is forty miles a day with weapons and armor.

Harold rested his men in London from October 6 to 11, then marched to Hastings, covering fifty-six miles in forty-eight hours. Again we have only estimates of the size of his army, but it is believed to have been around 9,000 men. He was badly outnumbered and only a third

of his men were first-rate troops. Still, it is difficult to see what else he could have done.

Harold took position on Senlac Ridge, about eight miles northwest of Hastings. On October 14, the Norman army advanced in three lines: archers, pikemen, and cavalry. William's archers fired first at too long a range, then fell back through their own lines to allow the pikemen to reach the enemy. The second line stormed forward but

were battered back from the ridge by rocks, spears, and furious hand-to-hand fighting.

William then led a charge up the ridge, but it too failed to penetrate. The Normans' left wing fell back, and Harold's soldiers rushed forward to take advantage of the left wing's weakness. Harold's army was set to crush the invaders as a rumor went around that William had fallen.

William threw off his helmet and rode up and down his lines to let his men see that he was alive. As well as being a splendid moment, his action does show the importance of charismatic leadership at this time, a tradition going back to Thermopylae. When they saw William, the Normans rallied and crushed their pursuers. Seeing how this strategy had worked to his advantage, William used the technique again. He staged a false cavalry panic and succeeded in drawing more of Harold's men from their position, his cavalry returning to cut them down. Yet most of Harold's men remained on the ridge, and the battle was far from over.

Many assaults by infantry, archers, and cavalry followed. Harold's forces were exhausted by midafternoon, but their courage had not faltered and they had sent back every attack against them. At that point, a chance arrow struck Harold in the eye, wounding him mortally. Morale plummeted and the English lines began to fail.

In terms of historical effect, this battle was the seed that would flower into the largest empire the world has ever known. Countries like Germany, Belgium, and Italy have existed only as nation states in the last couple of

centuries, but England has maintained its identity for a thousand years.

On Christmas Day 1066, in Westminster Abbey, William I was crowned King of England.

5. CRÉCY
August 26, 1346

This battle was part of the Hundred Years' War. Fighting was not absolutely constant between 1337 and 1453, but there were eight major wars between France and England over the period. In addition, the French supported the Scots in their almost constant wars with England. It was a busy time, and the period is fascinating—well worth a more detailed look than can be attempted here.

Edward III of England had declared himself King of France in 1338, a statement that did not go down well with the French King, Philip VI. In support of his claim, Edward invaded with a professional, experienced army of 3,000 heavy cavalry knights, 10,000 archers, and 4,000 Welsh light infantry. An additional 3,000 squires, artisans, and camp followers went with them. It is worth pointing out that the English longbow took more than a decade to learn to use well. It could not simply be picked up and shot, even after weeks of training. The strength required to fire an arrow through iron armor was developed only after years of building strength in the shoulders. It was necessary to start an archer at a young age to achieve the skill and power of those at Crécy.

Edward had failed to bring Philip to battle on two previous occasions. In 1346 he landed near Cherbourg and began a deliberate policy of the utter destruction of every French village and town he came to. In this way, Philip had to make an active response, and his army marched against the English at the height of summer.

(The story of the early maneuvers make excellent reading, especially Edward's crossing of the Somme river, made possible only by his archers and neat timing. The Osprey military book *Crécy 1346: Triumph of the Black Prince* by David Nicolle is well worth buying.)

To counter the English longbows, Philip did have Italian crossbowmen, but they needed a protective wicker shield while they reloaded; these were still with the baggage train for this battle, leaving them vulnerable. Nevertheless, the French force outnumbered the English three to one, with 12,000 knights and men at arms, 6,000 crossbowmen, 17,000 light cavalry, and as many as 25,000 foot conscripts. They were not well prepared when they came up against the English lines, however.

Philip's first action was to send his crossbowmen out to lay down fire. They moved forward and shot at 150 yards. Most of the bolts fell short and they advanced to fire again. This brought them inside the killing range of the English longbows, and a storm of arrows struck them.

The French knights saw the Italian crossbowmen falter and assumed they had lost their nerve. The knights were so eager to attack that they rode down their own allies to get through to the front, killing many. Then they

too were in range of the English longbowmen, and the thundering cavalry charge was torn apart. Those who did make it to the English lines were met by unsmiling veterans carrying axes and swords.

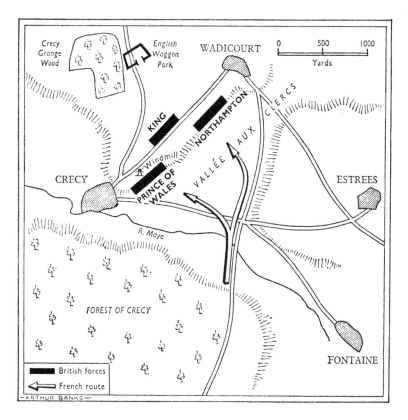

FAMOUS BATTLES—PART ONE

Charge after wild charge followed and was destroyed by the archers and the grim men behind them. Edward's son, the Prince of Wales, played a part, though at one point his position was almost overrun by the maddened French. His father refused to send him aid, saying that he must win his spurs.

We know the exact number of French aristocracy killed, because careful records were kept: 1,542 knights died that day. The number of common dead is less certain—somewhere between 10,000 and 20,000 is the best estimate. In comparison, the English forces lost 200 men, including 2 knights, 40 men-at-arms, and the rest from the Welsh infantry.

Crécy was a humiliation for the French king. It meant that Edward was able to go on to capture Calais on the north coast of France, which remained an English possession for almost two centuries.

Philip died in 1350, succeeded by his son, John, who was captured at the Battle of Poiters in 1356 by the Prince of Wales, then kept in London and held for a ransom of 3 million gold crowns. He never regained his father's throne.

This was not the last battle where cavalry played a part, far from it. After all, Winston Churchill took part in a cavalry charge in his youth some five hundred years later. Yet Crécy does mark the end of the *dominance* of cavalry. It showed the future was with infantry and projectile weapons, at least until the tank was invented.

UNDERSTANDING GRAMMAR— PART TWO

—⁂—

GRAMMAR DOES BECOME more complicated when you look at sentences, as you might expect. However, there are, in fact, only four *kinds* of simple sentences.

The Four Kinds of Sentences

1. **Imperative** (Command)—"Get out of my office!"
2. **Interrogative** (Question)—"Did you take my keys?"
3. **Exclamative** (Exclamation)—"Fantastic!"
4. **Declarative** (Statement)—"You are not my friend."

So you see, a simple sentence can be very simple indeed. It needs a subject and a verb to be a sentence, and so you need to know what a subject is.

Subject and Object— Nominative and Accusative

The **subject** of a sentence is the person or thing acting on the verb. "The man kicked the dog" has "the man" as the subject. It does get a little harder to spot with the irregular verbs—"John is sick" still has "John" as the subject. The

nominative form of words all have to do with the subject. This is crucial when it comes to pronouns, as the pronoun you use will depend on whether it is the subject or object in a sentence.

The **object** of the sentence is the person or thing on which the verb acts. "The man kicked the dog" has "the dog" as an object. The **accusative** forms of words all have to do with the object.

Before we go on to explaining nominative and accusative in more detail, you should know that imperative or exclamative sentences often have an invisible or implied subject. "Get out!" does have a subject—the person doing the getting out, even though the word isn't included. "Fantastic!" as an exclamation implies "That is. . . ." The verb is there in a sense, but not seen. All other sentences have a subject and a verb. Easy.

Nominative/Accusative
⌒ Pronouns ⌒

When a pronoun is in the subject part of a sentence, we use nominative case pronouns. These are : *I, you, he, she, it, we, they, who,* and *which.*

He went home.
> *not*
> "Him went home."

He and I were good friends.

not

"Him and me were good friends."

She and Susan were going home.

not

"Her and Susan were going home."

We went to the park.

not

"Us went to the park."

Who struck Tim?

not

"Whom struck Tim?"

In the above examples, the pronouns are all acting on the verbs, making it correct to use the nominative or subject form.

The accusative is the object part of a sentence. In the case of a pronoun, if it has the verb acting on it, we use *me*, *you*, *him*, *her*, *it*, *us*, *them*, *whom*, and *which*.

Susan went with him.

not

"Susan went with he."

John loved her.

not

"John loved she."

David enjoyed playing chess with them.

not

". . . chess with they."

Why not come with us?
> *not*
> "Why not come with we?"

We did not know whom to thank.
> *not*
> ". . . who to thank."

Some of these examples are fairly obvious. No one with the most casual knowledge of language would say "John loved she." However, "who" and "whom" cause problems still. It is worth giving those two words a small section of their own.

ᴄ⃕ **Who and Whom** ᴄ⃔

Learn this: If the word in question is acting on a verb (subject/nominative), use "who." If it is being acted upon (object/accusative), use "whom." Be careful—this is tricky.

Examples:

1. *The man who walked home was hit by a bus.* Correct or incorrect? Well, the "who" in question is doing the walking, so it is in the nominative form=accusative= correct. (You would not say "Him was hit by a bus," but "He was hit by a bus.")
2. *The man whom we saved was hit by a bus.* Correct or incorrect? This time, the man has been saved. The

verb is acting on him. He is not doing the saving, so it is in the object form=accusative=correct to use "whom" here. (You would not say "We saved he," but "We saved him.")

3. *He was walking with his mother, whom he adored.* Correct or incorrect? She is not doing the adoring. The "who" or "whom" in question is being acted upon by the verb and therefore should be in the object form=accusative=correct.

Finally, for the "who" and "whom" section, prepositions must be mentioned. Most examples of "whom" are used when it is the object of a preposition. Note that it is still the accusative form. There is nothing new here, but this one gives a great deal of trouble. The form often comes as sentences are rearranged so as not to leave a preposition at the end. It has the added bonus of putting a key word at the end of the sentence, which works very well for emphasis.

1. *He was a man for whom I could not find respect.* If this had been written, "He was a man I could not find respect for," it would have been wrong. "For" is a preposition and you just don't end a sentence with them. Note that it could have been written "He was a man I could not respect" to avoid the problem. This is laziness, however. Learn it and use it.

2. *To whom it may concern*—a formal opening in letters. Note that such a letter should be ended, *Yours faithfully.*

If the letter begins with a name, *Dear David*, for example, it should end with *Yours sincerely*.

A final mention of pronouns in the accusative must be made. It should now be clear enough why it's "between you and me"—the "me" is in the accusative, acted on by the preposition "between." You would not say, "He gave the car to I," which has "to" as a preposition, or "Come with I." Similarly, you don't say, "Between you and I."

As You Now Know
⌐ Nominative and Accusative . . . ⌐

For the record, **genitive** has to do with possessive words: *mine*, *my*, *his*, *hers*, *ours*, etc. Easy.

Dative is the term used to describe an indirect object. In the sentence "Give me the ball," "the ball" is the object, or accusative. However, "me" is also in the accusative, as if the sentence had been written "Give the ball to me." The word "me" is "in the dative"—an indirect object.

Note that dative is of very little importance in English. In Latin, sentence word order is less important. "The man bites the dog" can be written as "The dog bites the man"—and only the endings will change. As a result, the word endings become crucial for understanding. English has evolved a more rigid word order and so the dative, for example, has become less important. It's still satisfying to

know it, though, and most modern English teachers can be made to glaze over with a question on this subject. That said, if you try it on a Latin teacher, you'll be there all day.

The **ablative** case is another one more relevant to the study of Latin than English. It involves words that indicate the agent or cause of an event, its manner, and the instrument with which the action is done. The ablative case is likely to be used in sentences with the words "from," "in," "by," and "with"—prepositions. "They proceeded *in silence*," for example, shows the manner in which they proceeded. "He was beaten *with sticks*," shows how he was beaten. Those phrases are "in the ablative."

⮌ Clauses and Phrases ⮍

Simple sentences are not the whole story, of course. A complex sentence is one that has two or more clauses, but what is a clause?

The simplest working definition of a **clause** is that it has a subject and a verb and is part of a larger sentence. Sometimes the subject is understood, or implied, but the verb should always be there. The following example is a sentence with two clauses, joined by the conjunction "so": "I could not stand the heat, so I leaped out of the window."

In a sense, clauses are mini-sentences, separated either by conjunctions or punctuation.

This sentence has four clauses: "Despite expecting the voice, I jumped a foot in the air, smashed a vase, and rendered my daughter speechless."

"Despite expecting the voice" is a subordinate clause, separated by a comma from the rest. (Subordinate means lesser—a clause that could be dropped without destroying the sentence.) "I jumped a foot in the air" is the second clause, "smashed a vase" is the third, and "rendered my daughter speechless" is the last. The final two are joined with the conjunction "and."

Note that "smashed a vase" has the subject implied from the "I" earlier on.

Subordinate clauses cannot stand on their own. Main clauses like "I jumped a foot in the air" are complete sentences, but "Despite expecting the voice," is not. On its own, it would beg the question "Despite expecting the voice . . . what?"

Phrases are groups of words that do not necessarily contain a verb and subject. Expressed simply, they are every other kind of word grouping that is not a clause or main sentence. A phrase can even be a single word.

The main kinds of phrase: adjectival (works like an adjective); adverbial (works like an adverb); noun (works like a noun); prepositional (works like a preposition); and verb (works like . . . um, a verb). If you want to impress English teachers, ask them if part of a sentence is using an adjectival or prepositional phrase.

Examples:

1. "I lived *in France*." "In France" is a prepositional phrase, as it is a group of words indicating position.
2. "I thought you wanted to leave *early tonight*" is an adverbial phrase, as "early tonight" modifies the verb "leave."
3. "It was an elephant *of extraordinary size*." "Of extraordinary size" is an adjectival phrase, as it adds information to the noun "elephant."
4. "*The bearded men in the room* stood up and left." This is a noun phrase—it's just a more complicated name for the men, using more than just one word.
5. A verb phrase is a group of words often containing the verb itself—an exception to the general rule that phrases won't have verbs. "You *will be going* to the play!" has "will be going" as a phrase of three words combining as the verb.

In contrast to complex sentences, "compound" sentences have either multiple subjects: "You and I are going to have a little chat," or multiple verbs: "He choked and died."

EXTRAORDINARY STORIES—
PART TWO

The Wright Brothers

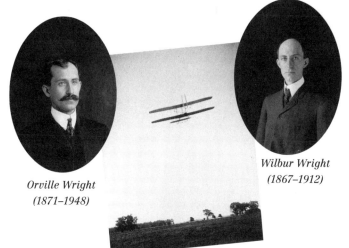

Orville Wright
(1871–1948)

Wilbur Wright
(1867–1912)

Up until the twentieth century, man looked up at the skies, watched birds glide across the heavens, and imagined what it would be like to fly. Human flight was an unrealized dream until December 17, 1903, when two American men built and successfully flew the world's first powered, controlled machine.

In 1878, twenty-five years earlier, a man named Milton Wright brought home a toy for his two young sons, Wilbur and Orville. It was a helicopter made of paper, bamboo, cork, and a rubber band, based on an invention by Alphonse Pénaud, a French aeronautics pioneer. The boys played with it until it broke—then they built their own.

As they grew, the Wright brothers became very interested in technology, specifically printing and bicycle mechanics. They ran a press and a factory that made bicycles. Today, only five bicycles built by the brothers are still known to be in existence.

Wilbur and Orville's businesses made it possible for them to experiment in aeronautics. They began their experimenting in 1899, and one year later they were ready to attempt to fly their first glider. They chose Kill Devil Hill, at Kitty Hawk in North Carolina. A meteorologist had recommended the site because it had such strong winds, and the brothers enjoyed the isolated location—one that would keep busybodies away from their work. They weren't the only ones trying to build a flying machine.

The Wright brothers' glider was a piloted aircraft that measured 11 feet, 2 inches long and 4 feet, 3 inches tall, with a 17-foot wingspan. It weighed only 52 pounds and was crafted from 16-foot pieces of pine with wing ribs made of ash, and covered by one layer of French sateen fabric. The glider was a success: it flew.

The Wright brothers were onto something, and they kept on working. With every subsequent experiment, they improved on their previous designs. Three years later, at

the end of 1903, they were ready to test a powered aircraft, one that provided its own energy instead of relying solely on the wind. In order to build their new flyer, they hand-carved the propellers and had a man named Charlie Taylor build the engine at their bicycle shop.

In order to be able to fly with added weight from the engine, propellers, and reinforcements to the structure, they had to increase the wingspan to more than 500 square feet, up from 165 square feet on the glider. The flyer also had a three-axes control system and a rudder that could be moved. The right wing was designed to be 4 inches longer than the left to make up for the uneven weight of the horizontal, 4-cylinder, water-cooled 12-horsepower engine.

The day of the test, December 17, was bitterly cold, with winds blowing at 27 miles per hour. The very first flight was conducted by Orville, who flew 120 feet in 12 seconds. In the fourth and last flight of the day, Wilbur flew 852 feet in just under a minute. The altitude for their flights was about 10 feet. There were few witnesses, and only two newspapers wrote about the flight, one of them a local paper that got the story wrong.

The Wright Flyer later became known as Flyer 1, and later as *Kitty Hawk*. The original sketch of the 1903 Wright Flyer is at the Franklin Institute in Philadelphia. It was drawn in pencil on brown paper, with notes written by Wilbur. The original flyer can be seen in the Smithsonian Institution in Washington, D.C.

All airplanes created since have included the basic design of the 1903 Wright Flyer.

THE TEN COMMANDMENTS

WHAT TRANSLATORS OF modern versions of the Bible sometimes fail to appreciate is that the language of the King James Version has a grandeur, even a power, that their versions simply lack. It is no hardship to "walk through a dark valley." On the other hand, "the valley of the shadow of death" is a different matter. Frankly, the rhythm and poetry are part of the effect and not to be lightly cast aside. We can find no better example of this than the Ten Commandments themselves.

And God spake all these words, saying, I am the Lord thy God, which have brought thee out of the land of Egypt, out of the house of bondage.

1 *Thou shalt have no other gods before me.*

2 *Thou shalt not make unto thee any graven image, or any likeness of any thing that is in heaven above, or that is in the earth beneath, or that is in the water under the earth: thou shalt not bow down thyself to them, nor serve them: for I the Lord thy God am a jealous God, visiting the iniquity of the fathers upon the children unto the third and fourth generation*

of them that hate me; and shewing mercy unto thousands of them that love me, and keep my commandments.

3 *Thou shalt not take the name of the Lord thy God in vain; for the Lord will not hold him guiltless that taketh his name in vain.*

4 *Remember the sabbath day, to keep it holy. Six days shalt thou labour, and do all thy work: but the seventh day is the sabbath of the Lord thy God: in it thou shalt not do any work, thou, nor thy son, nor thy daughter, thy manservant, nor thy maidservant, nor thy cattle, nor thy stranger that is within thy gates: for in six days the Lord made heaven and earth, the sea, and all that in them is, and rested the seventh day: wherefore the Lord blessed the sabbath day, and hallowed it.*

5 *Honour thy father and thy mother: that thy days may be long upon the land which the Lord thy God giveth thee.*

6 *Thou shalt not kill.*

7 *Thou shalt not commit adultery.*

8 *Thou shalt not steal.*

9 *Thou shalt not bear false witness against thy neighbour.*

10 *Thou shalt not covet thy neighbour's house, thou shalt not covet thy neighbour's wife, nor his manservant, nor his maidservant, nor his ox, nor his ass, nor any thing that is thy neighbour's.*

(Exodus 20:1–17)

A BRIEF HISTORY OF ARTILLERY

———⟶✦⟵———

THE ABILITY TO strike an enemy from far away has always appealed to soldiers and generals alike. Bows have been found from as early as 7400 BC, preserved in a bog at Holmegaard, Denmark. They may go back as far as 20,000 BC. Though such weapons were powerful and accurate, there has always been a search for more destruction and greater range. A city cannot be battered into submission by archers, after all.

Archimedes is one of the most famous early inventors of artillery weapons. In the defense of Syracuse in 214 to 212 BC, he used bronze mirrors to focus the sun and burn enemy ships.

The truth of this story was doubted for a long time. In the early 1970s, a Greek scientist, Dr. Ioannis Sakkas, employed sixty Greek sailors in an experiment to see whether it was possible. All the men carried large oblong mirrors and used them to focus the sun onto a wooden ship 160 feet away. The ship caught fire almost immediately.

Archimedes was an extraordinary thinker, the Leonardo da Vinci of an earlier age. He invented a number of other artillery weapons to sink Roman galleys, or hammer them from the city walls. He was not alone, however.

The Greeks developed knowledge of pulleys, water pumps, cranes, even a small steam engine. It was a period of extraordinary scientific advancement—all of which was useful in creating weapons of long-distance destruction.

Early weapons were based on the spring power of a bow arm, pulled back by muscle or by a ratchet, as in this picture. Understanding pulleys means that a man can repeat an easy action over and over to move large forces very slowly. In other words, heavy weapons can be wound back with the use of a few simple principles.

"Torsion" is the force gained by twisting. The Romans improved on Greek inventions, perfecting the use of ropes of woven horsehair and sinew as their "spring." The heavy Roman **Onager** was capable of sending a 100 lb. (45 kg) rock up to 400 yards (365 m). *Onager* is Latin for a wild ass or donkey, one with a fearsome kick. It is similar in

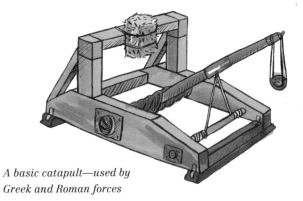

A basic catapult—used by Greek and Roman forces

principle to the catapult, with a slinglike cup and a single torsion bar.

The **Ballista** was a Roman bolt or stone shooter. It used two torsion springs and had a range of up to 450

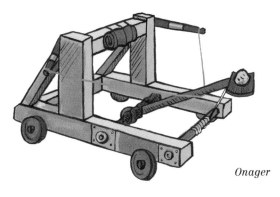

Onager

yards (411 m). The Romans also perfected a *repeating* ballista, invented by Dionysios of Alexandria. By simply winding a handle, the ratchet came back; an arrow dropped into place was fired as soon as the winch reached its maximum point. This was the first machine gun— long before gunpowder.

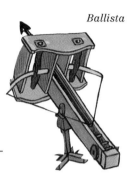
Ballista

Every Roman legion carried heavy onagers and thirty **Scorpion** bows, a smaller form of the weapon that could be carried on a single cart. Roman success in war depended on much more than discipline and a good gladius!

The last type of this sort of engine is a **Trebuchet**, powered by counterweights. This form of artillery was able to launch heavier weights than any other kind. However, the enormous counterweight needed meant that Trebuchets were practically immobile once set up and worked well only when battering city walls. They were in use

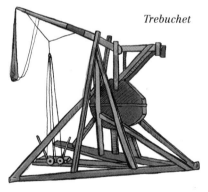
Trebuchet

throughout medieval times until the invention of the cannon. Pulleys and ratchets were used to pull down the arm and load it. When released, the arm snapped forward and the second section whipped over at high speed.

Later, gunpowder and iron-foundry techniques combined to create smooth-bore cannons. Compared with early engines of war, these had a much longer range and were faster to load. Although China had gunpowder in the eleventh century, it was European countries that really exploited its use as a propellant in the thirteenth century. Roger Bacon, the English Archimedes, wrote down a formula for gunpowder in code in the thirteenth century. The combination of sulfur, charcoal, and potassium nitrate, or saltpeter, would change the Western world.

The picture below is of "Mons Meg," a Flanders cannon cast before 1489 and currently kept in Edinburgh castle.

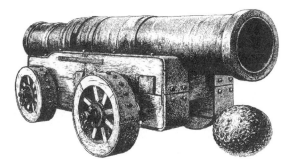

It fired a stone ball of 330 lb. (150 kg) more than one and a half miles (2.4 km).

For the next six hundred years, cannons would remain essentially the same—smooth-bore muzzle loaders, lit by a taper or a flintlock. Iron balls would be used instead of stone as they were easier to mass produce and make uniform. Cast-iron barrels took the place of softer wrought iron. Cannons at sea could fire chain, or bar shot, to destroy enemy rigging and clear the decks of boarding parties. In the basic principles, though, Nelson's cannons fired in the same way as those from the thirteenth century. As with most long-lasting technologies, if they weren't replaced, they were perfected.

Mortars and **howitzers** were also perfected during the nineteenth century. A mortar fires at very high angles compared with a cannon; a howitzer between the two. Progress was fast and furious, since a single clear advantage could mean the difference between winning a war and being invaded.

Rifling a barrel involves casting spiraling lines inside that make the ball or shell spin as it leaves, giving gyroscopic stability. Although it had long been in use for hand weapons, the practice was first applied to artillery around 1860. The new breed of artillery would be breech-loading, have reinforced barrels, and be able to fire shells with astonishing accuracy.

The heaviest versions of these shell-firing weapons could be miles behind the lines, firing huge shells in a parabola (arc) at the enemy positions.

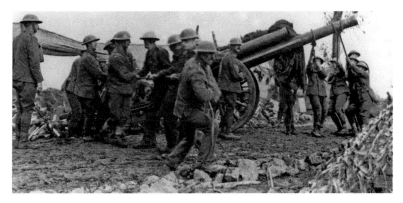

World War I British fieldpiece, firing sixty-pound explosive shells

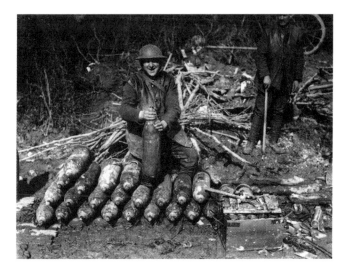

No chapter on artillery could be complete without a mention of **tanks**. From WWI on, these awesome machines have changed the face of warfare by allowing powerful artillery to be extremely mobile and well armored.

In modern times artillery can take the form of intercontinental missiles, striking from hundreds or even thousands of miles away and with a greater force than anything else mentioned in this chapter. In a sense, artillery has reached its ultimate stage, where cities can be flattened without a single soldier entering the combat zone.

Shells can now be armored in "depleted uranium"— uranium with most of the radioactive isotopes removed. This is a heavy metal and hard enough to be ferociously

The twenty-first century—U.S. MIAZ Abrams MBT

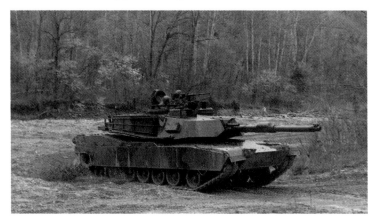

efficient as an armor-piercing round. Although it is actually less radioactive than naturally occurring uranium, it is chemically toxic and should not be ingested. Dust and fragments from DU shells remain dangerous for a very long time.

We have come a long way from bow-based spring weapons. Until the invention of the machine gun, it was still possible to march into cannon fire and expect at least some of your army to reach the enemy. World War I changed that, the obsolete tactic going the way of the cavalry charge. It is difficult to predict the course of the future, with such immensely powerful weapons now available. Wars these days tend to be fought on a small scale, with major players being very careful to limit the destruction. In theory, Britain could have dropped nuclear weapons on Argentina during the Falklands War, or America on Iraq in the first or second Gulf War. Neither country took that step. Let us hope it does not happen in our lifetimes.

TIMERS AND TRIPWIRES

———※———

THESE ARE VERY simple to make—and deeply satisfying. For the timer, any wind-up alarm clock will do, preferably one with plastic hands. The idea is to use the clock to complete a circuit and turn on a light. You want the bulb to turn on in twenty minutes—to win a bet perhaps, or to frighten your little sister with the thought that a mad ax murderer is upstairs.

First, remove the plastic front of the clock. Tape wire to each hand, so that when one passes under the other, the bare ends will touch. It should be clear that a circuit can now be made with a time delay of however long it takes the minute hand to travel around and touch the hour hand.

Attach one of the wires to a positive battery terminal. Tape a flashlight bulb to the negative terminal and the

end of the other wire to the end of the bulb. Test it a few times by touching the hands of the clock together. The bulb should light as the wires on the hands touch and complete the circuit.

Bear in mind that the hour hand will have moved by the time the minute hand comes around, so it's worth timing how long it takes for the bulb to light after setting the minute hand to, say, fifteen minutes before the hour. You can then terrify your young sister with the tale of the man with a hook for a hand.

TRIPWIRE

This is almost the same thing, in that it uses a battery circuit with a bulb linked to a switch—in this case a trip-wire. With a long enough wire, the bulb can be lit some way from the actual trip switch for longer warning times.

Wrap foil around the ends of the wooden or plastic clothespin. Attach your wires with tape to those foil ends, running both to exactly the same battery and bulb setup as the alarm-clock switch.

The important thing is to have a nonconducting item between the jaws of the clothespin. We found a wine cork worked quite well. The wire itself must also be strong enough to pull the cork out—if it snaps, the bulb won't light. Fishing line is perfect for this because it's strong and not that easy to see. It is also important to secure the clothespin under a weight of some kind. Only the cork should move when the wire is pulled.

When the cork is pulled out, the jaws of the pin snap shut, touching the foil ends together, completing the circuit and lighting the bulb to alert you.

This works espe-

cially well in tall grass, but its main disadvantage is that whoever trips the switch tends to know it has happened. Enemy soldiers would be put on the alert, knowing they were in trouble. Of course, in a real conflict, the wire would have pulled out the pin to a grenade.

PRESSURE PLATE

One way of setting up a trip warning without the person realizing is with a pressure plate. Again, this relies on a simple bulb circuit, but this time the wires go to two pieces of cardboard held apart by a piece of squashable foam. A small sponge would also be perfect.

This time, tape foil squares over the bare ends of the wires on the inner surfaces of the cardboard and set up a simple bulb and battery circuit as before. With only light pressure from above, the two bits of cardboard come together, bringing the foil squares into contact. The circuit is made, and the warning bulb comes on. Enjoy.

Carpet Foil Square Crushable foam

THE ORIGIN OF WORDS

---✵---

ENGLISH IS AWASH with interesting words and phrases; there are books the size of dictionaries chock-full of them. Here are twenty of our favorites—words and phrases with origins so interesting they should be part of general knowledge.

1. **Boycott.** Captain Charles Cunningham Boycott was a rent-collecting agent for an English landlord in Ireland in the nineteenth century. He was considered particularly harsh and locals refused to have anything to do with him. His name became a word meaning "to ostracize." It is used as a verb—"to boycott," and as a noun—"the boycott went well."

∞

2. **Halloween.** "Hallow" is an old pronunciation of "Holy," still sometimes found in the alternative version, "All Hallows Eve." The "-een" part is a common contraction of the word "evening." "Halloween" means "Holy evening"—also known as "All Saints Eve."

∞

3. **Hooligan.** Almost certainly derived from the surname of an Irish family, "Houlihan," whose name

became synonymous with bad behavior in the late nineteenth century.

<div style="text-align:center">∽☙</div>

4. **Quisling (pronounced "kwizling").** Norwegian Major Vidkun Quisling was a Norwegian politician who supported the Nazis in WWII. His name became synonymous with "traitor." He was shot for treason.

<div style="text-align:center">∽☙</div>

5. **Thug.** One of many Hindi words adopted into English (like "pyjamas" and "bungalow"). The "Thugs" were a sect of robbers and murderers in India.

<div style="text-align:center">∽☙</div>

6. **Gerrymander.** A word derived from the surname of Elbridge Gerry, an American politician who in 1812 rearranged electoral districts to gain advantage for the Republican party. The new district was jokingly said to be shaped like a salamander and was depicted as such in a political cartoon that coined the term "gerrymander." His name has come to describe plans to win elections dishonestly. His name began with a hard "g," but the sound is soft on the word (jerry-mander).

<div style="text-align:center">∽☙</div>

7. **Assassin.** The Arabic word "hashshashin," meaning "hashish eaters," was the name given to a violent Syr-

ian sect in the Middle Ages. To create a murderous frenzy, they took hashish (cannabis) while chanting and dancing. The English word "assassin" ultimately derives from this.

❧

8. **Whiskey.** From the Gaelic "uisge beatha" (ISHka BA-ha)—meaning "water of life." Other languages use very similar phrases: "aquavit" for strong spirit in Scandinavia, "eau-de-vie" for brandy in France, "aqua vitae" in Latin. "Vodka" is Russian for "little water."

❧

9. **Tawdry.** Meaning cheap and flashy. This word comes from the phrase "St. Audrey's lace." St. Audrey was a seventh-century princess of East Anglia who took religious orders. As a girl, she had been very fond of necklaces, and when she succumbed to a throat disease she felt it was punishment for her vanity. "St. Audrey's lace" or "tawdry lace" was tainted, or flawed, and came to mean flashy and poor quality.

❧

10. **Bloody.** "Bloody" is thought to be a corruption of "By our Lady" and one that has fallen out of use; "Gadzooks!" is a form of "God's hooks," making reference to the nails used in the crucifixion of Jesus. The Aus-

tralian "Strewth!" similarly, is a contraction of "God's Truth." Even oaths can have interesting histories.

❧

11. **Exchequer.** In Norman England, money-counting tables were often covered in a checkered cloth. The practice was common enough for the table to become known as an "eschequier," meaning "chessboard," and the word transferred to English as "exchequer," a word for the treasury.

❧

12. **Auspicious/augury.** In English, the words have to do with telling the future. "It seemed an auspicious moment to apply for his job, when Jenkins fell down the well." Both have their roots in the Roman practice of using the flight of birds to tell the future. An expert in this field was known as an "auspex," derived from a combination of "avis," meaning "bird," and "specere," "to look." These charlatans were literally "lookers at birds," and the word still survives after two thousand years.

❧

13. **Chivalry.** The moral code of knights, who tended to ride horses. The name is derived from the French word for horse, "cheval," which in turn comes from the Latin "caballus." "Cavalier," meaning off-hand or

"too casual" (a cavalier attitude), also comes from the same root.

❧

14. **Chortle.** A word invented by Lewis Carroll (writer of *Alice in Wonderland*) as a combination of "chuckle" and "snort." This type of combination is known as a "portmanteau" word. He also invented the word "portmanteau" to describe words of this type, like "brunch," which is a combination of "breakfast" and "lunch." Clever man.

❧

15. **Conspire/Expire/Respire.** All these words have their origin in the Latin "spirare," to breathe. Conspirators breathe their plots together. A man who "expires" has the breath go out of him. Respiration is breath.

❧

16. **Denim.** This is one of many products linked to its place of origin. The hard-wearing cloth was created in Nimes, an industrial town in southern France. It was known first as "serge de Nimes" and then as "de Nimes."

❧

17. **Laconic.** The region inhabited by the Spartans of ancient Greece was named Laconia. Philip of Mace-

donia (the father of Alexander the Great) sent this warning to the famous warriors of the city, to frighten them into obedience: "If I enter Laconia with my army, I shall raze Sparta to the ground." The Spartans replied with a single word: "If." "Laconic" means "terse," or "to the point," in recognition of the Spartan style. The word "Spartan," meaning "bare and without ornamentation," also comes from that warrior culture.

<div align="center">☙</div>

18. **Shambles.** Although it is now used to mean a chaotic scene, this word originally meant a slaughterhouse. In fact, reference to the fact that shambles were relocated after the great fire of London in 1666 can be found on Christopher Wren's monument. The word origin goes even farther back to Old English for a table, "scamul," which is connected with the Latin for "bench," "scamnum." Rows of these would form a meat market.

<div align="center">☙</div>

19. **Mob.** This word is simply a contraction of the Latin phrase, "mobile vulgus" (MOB-e-lay, VULG-ous). "Mobile" means "fickle" and "Vulgus" means "crowd."

<div align="center">☙</div>

20. **Quick.** In Old English, "cwic" meant "alive," a meaning we still see in "quicksilver," another name for mer-

cury, because the liquid metal seems almost to be a living silver. You may also have heard the phrase, "the quick and the dead," meaning "the living and the dead," or "cut to the quick," meaning "cut to the living flesh." "Quick-tempered" also retains some sense of the original sense, though the modern meaning has mainly to do with speed alone.

THE GREATEST PAPER
AIRPLANE IN THE WORLD

IN THE 1950s, an elementary school headmaster found a boy throwing paper airplanes from a high window. The head was considering punishment when he noticed the plane was still in the air, flying across the playground below. The boy escaped a detention, but he did have to pass on the design to the schoolmaster—who passed it on to his own children. You will find more complicated designs, and you may be sold the idea that the best planes require scissors and lessons in origami. This is nonsense.

The plane on the right—the Harrier—is simple, fast, and can be made from a letter-sized sheet of paper. It is the best long-distance glider you'll ever see—and with a tweak or two, the best stunt plane. It has even won competitions. One even flew the entire road from a hotel balcony next to Windsor Castle on New Year's Eve. Four other planes hit the pavement, but this one sailed clear across. The one on

the left—the Bulldog Dart—is a simple dart, a warm-up plane, if you like. It's a competent glider.

The Bulldog Dart

1. Fold a letter-sized sheet of paper lengthways to get a center line.
2. Fold two corners into the center line, as in the picture.
3. Turn the paper over and fold those corners in half, as shown.

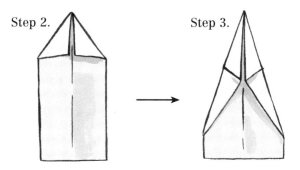

4. Fold the pointy nose back on itself to form the snub nose. You might try folding the nose underneath, but both ways work well.
5. Fold the whole plane lengthways, as shown.
6. Finally, fold the wings in half to complete the Bulldog Dart.

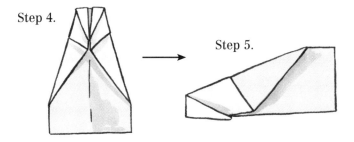

Step 4.

Step 5.

The Harrier

1. Begin in the same way as the Bulldog Dart. Fold in half lengthways to find your center line and then fold two corners into that line, as shown.
2. Fold that top triangle down. It should look like an envelope.
3. Fold in the second set of corners. You should be able to leave a triangular point sticking out.

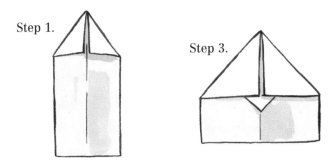

Step 1.

Step 3.

4. Fold the triangle over the corners to hold them down.
5. Fold in half along the spine, leaving the triangle on the outside, as shown.
6. Finally, fold the wings back on themselves, finding your halfway line carefully. The more care you take to be accurate with these folds, the better the plane will fly.

Step 4.

Step 5.

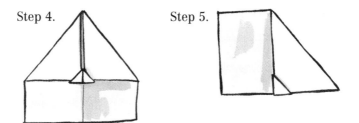

Step 6.

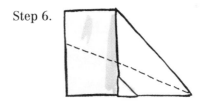

This plane does well at slower launch speeds. It can stall at high speed, but if you lift one of the flaps slightly at the back, it will swoop and return to your hand or fly in a great spiral. Fiddle with your plane until you are happy with it. Each one will be slightly different and have a character of its own.

THE GOLDEN AGE OF PIRACY

⟹✦⟸

THERE HAVE BEEN pirates for as long as ships have sailed out of sight of land and law. The period known as "the golden age" of piracy began in the seventeenth century and continued into the early eighteenth. The discovery of the New World and vast wealth there for the taking caused an explosion of privateers—some, like Francis Drake, with the complete authority and knowledge of Queen Elizabeth I.

The word "buccaneer" comes from European sailors who caught wild pigs on the islands of Haiti and Tortuga in the Caribbean and smoked the meat on racks to preserve it. The French *boucaner* means to dry meat in this fashion. The men referred to themselves as the "Brethren of the Coast," and it is from them that the most famous names came, like Calico Jack Rackham and Blackbeard. Perhaps the most astonishing thing about the golden age is the fact that many pirates were given pardons, sometimes in exchange for military aid or a cut of the loot. The Welsh privateer Henry Morgan was not only pardoned but knighted by Charles II, made acting governor of Jamaica, a vice admiral, commandant of the Port Royal Regiment, a judge of the Admiralty Court, and a justice of the peace!

Although the skull and crossbones, or "Jolly Roger," is

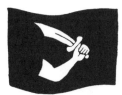

Thomas Tew

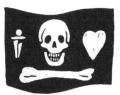

Stede Bonnet

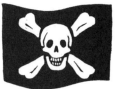

Richard Worley

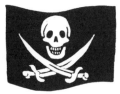

Jack Rackham

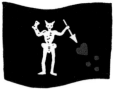

Blackbeard

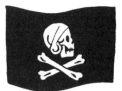

Henry Every

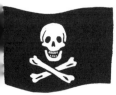

Edward England

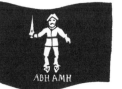

Bart Roberts (2nd)

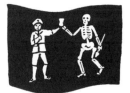

Bart Roberts

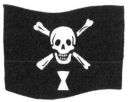

Emanuel Wynne

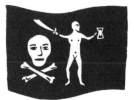

Walter Kennedy

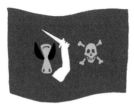

Christopher Moody

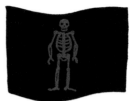

Edward Low

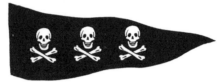

Christopher Condent

by far the most famous pirate flag, there were different versions and many other flags that would send fear into the hearts of merchant sailors and their captains. Here is a selection of the most famous, as well as the men who sailed under them.

GRINDING AN ITALIC NIB

Although the pen we used is an expensive model, this should absolutely not be tried with a valued pen. There is a reasonable chance of destroying the nib completely and the nib is usually the most expensive part to replace. The rest, after all, is just a tube.

The first thing to know is that *almost all* italic nibs are hand-ground. In theory, there is no reason why you should not be able to grind a nib to suit you, with a little common sense and care.

Before you begin, it is a good idea to get hold of an italic nib and try writing with it. The writing style is quite different and the nib tends to be "scratchier." It is extremely satisfying knowing you have ground your own nib—and the handwriting is attractive.

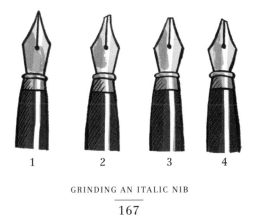

1 2 3 4

Picture 1 shows a standard nib. Picture 2 would be best suited to a left-handed writer. Picture 3 is suitable for both and 4 is best suited for right-handers. It's difficult to change from one to the other if you are not happy with the result, which is why you should try a shop-bought italic nib first.

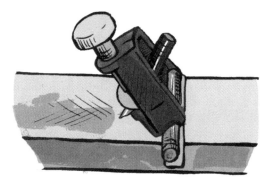

We used a sharpening gig—a useful little gadget that helps to hold chisels at the required angle. A fine sharpening stone will take longer, but as delicate as this task is, it is probably a good idea. No matter how you choose to sharpen, stop often, dip the nib in ink, and try it out. Do not be discouraged by scratching at this stage.

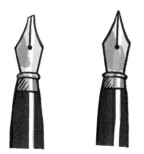

You should arrive somewhere near the nib on the left if you are left-handed. It was identical to the nib on the right before grinding. Attempts at writing with the new angle may be initially discouraging. Very fine sandpaper (or wet and dry paper) is needed to smooth away roughness and dust from the grindstone. It is a matter of personal preference how far you smooth the corners, but we found it helped the easy flow of ink.

All the King's horses and all the King's men

All the King's horses and all the King's men

NOTE: This is not italic or copperplate lettering. Those alphabets have to be learned, though they are based on the wide and narrow strokes of an italic nib.

FAMOUS BATTLES—PART TWO

———✳———

6. THE BATTLES OF LEXINGTON
AND CONCORD
April 19, 1775

Listen, my children, and you shall hear
Of the midnight ride of Paul Revere,
On the eighteenth of April, in Seventy-Five;
Hardly a man is now alive
Who remembers that famous day and year
>—Henry Wadsworth Longfellow,
>"Paul Revere's Ride"

By the rude bridge that arched the flood,
Their flag to April's breeze unfurled;
Here once the embattled farmers stood;
And fired the shot heard round the world.
>—Ralph Waldo Emerson,
>"Concord Hymn"

THE BATTLES OF Lexington and Concord, fought on April 19, 1775, marked the beginning of the Revolutionary War. They were fought in Massachusetts, in a string of towns near Boston. The towns involved were Lexington, Concord, Lincoln, Menotony, which we now call Arlington, and Cambridge.

Paul Revere's Ride

On April 18 the British army, led by Lieutenant Colonel Francis Smith, left Boston for Concord. There were 800 soldiers on a mission to capture a cache of weapons and other supplies that the militia in Massachusetts had hidden in Concord. The British had no idea that the arsenal in question was no longer there. The Minutemen had received intelligence reports weeks before, giving them time to move the equipment to a secure location. The patriot militias were called Minutemen because, although they weren't professional soldiers, these farmers and fathers still had to be ready to fight at a minute's notice.

Lucky for the patriots, they were about to receive an-

other warning, this time of the imminent British advance. Schoolchildren everywhere are familiar with the name of Paul Revere because his midnight ride to warn the colonists was made into legend by Longfellow's poem, although not while the hero was alive. Really, though, there was more than one rider.

In Charlestown, a man named Dr. Joseph Warren paid two men to ride to Lexington and Concord to notify the Minutemen that the British army was coming. The first men who rode to warn the militias were William Dawes and Paul Revere. As the story goes, Paul Revere yelled as he rode, "The British are coming! The British are coming!" In actuality, what he called to the houses was "The regulars are out!"

On their way, Revere and Dawes met a doctor named Samuel Prescott, who joined their ride. They made Lexington at midnight, notifying John Hancock and Samuel Adams of the approach of the "regulars."

Revere, Dawes, and Prescott were captured by the British at a roadblock in Lincoln. Prescott and Dawes were able to slip away, and Prescott reached Concord to let them know that the British were on their way. Revere's horse was taken away; when they released him, he had to walk back to Lexington. He arrived in Lexington in time to see the first shots of the battle.

The first shot fired is famously known as the "shot heard round the world," written about by Ralph Waldo Emerson in his poem "Concord Hymn." The gunfire launched the Battles of Lexington and Concord, touching

off the war that would win the thirteen colonies of British North America their independence, and begin the United States.

At Lexington, as the British army advanced, the Minutemen realized they were terribly outnumbered. They fled. In Concord, though, it was a different story. A group of patriots battled three companies of British soldiers; in this battle, it was the king's men who turned and ran.

Over the next few hours, more patriots arrived. The colonists inflicted more punishment on the British soldiers marching back from Concord. Captain Smith's group was saved at Lexington by British reinforcements commanded by Lord Percy Hugh, and both regiments, 1,900 men in total, withdrew to Charlestown.

Most of the British made it back safely, but they didn't capture any important weapons or supplies.

7. THE ALAMO
February 23–March 8, 1836

Texas, the twenty-eighth state of the United States, was independent for almost ten years before joining the United States in 1845. Before 1836 Texas was part of New Spain, a Mexican colony. In order to gain independence from Mexico, the colonists in Texas fought the Texas Revolution, a battle that lasted from October 2, 1835, until April 21, 1836.

In 1835 the president of Mexico was General Antonio López de Santa Anna Perez de Lebron. He abolished the

FALL OF THE ALAMO.

constitution that had been set up in 1824, taking the power away from the local governments and making sure that control would be concentrated in his presidency. Santa Anna was nervous about the expansion of the United States, and he wanted to be sure that Texas would remain a part of Mexico.

The colonists in Texas didn't feel the same way. While the colonies were very successful, they were writhing under the Mexican system. Under the Mexican laws, trade was restricted and all official business was supposed to go through Mexico City, which encouraged smuggling, and meant that if you lived far from Mexico City, you had to deal with extra taxes and hassles. Texans had always gotten their goods from Louisiana, and this economic relationship served only to strengthen their ideological bonds with the United States.

There were a number of reasons why Texans wanted their independence, but the breaking point was a fight between a Mexican soldier and a colonist. Settler Jesse McCoy was beaten to death with a musket, and what had been a discussion reached a fever pitch. The first battle of the Texas Revolution was the Battle of Gonzalez, on October 1, 1835.

A few months later, in early 1836, General Santa Anna decided to march to Texas and put the rebellion down once and for all. He led the Mexican army over mountains, through snowstorms, and across the Rio Grande. Santa Anna left Mexico with around 6,000 troops, but not all of his soldiers made it. The terrible weather was severe enough to kill men and horses, but the Mexican army kept going.

In order for Santa Anna and his army to reach the middle of Texas, they had to pass through San Antonio de Bexar, a village with a converted church that the locals called Misión San Antonio de Valero. We call it the Alamo. The Alamo had been a mission for many years, and it was certainly not designed for any military use, but the militia in Texas had equipped the Alamo with eighteen cannons. You could not find a larger group of cannons west of the Mississippi River, which meant that the Mexican forces would not be able to pass by and put down the revolt unless they captured the mission.

There were around 200 men in the Alamo, commanded by William Barret Travis and Jim Bowie. Jim Bowie is well known as a courageous figure in Texan lore. He grew up in Louisiana, but he came to Texas to join the revolution after getting into heaps of adventures. He worked with the French pirate Jean Lafitte, searched for silver mines, and got a reputation for having a red-hot temper.

Not all of the soldiers defending the Alamo were from Texas—and not all of them were soldiers. Bowie was there with a group of unofficial volunteers. The New Orleans Greys were there for the siege of Bexar, and more than twenty of them stayed behind to fight for the Alamo. On February 8, the Tennessee Mounted Volunteers arrived with the legendary Davy Crockett, who is known as the "King of the Wild Frontier."

On February 24, Santa Anna and the Mexican army arrived with infantry and cavalry. They had British

Brown Bess muskets and were trained to use them. They also had a few 6-lb. cannons. The army was professionally trained, with some European mercenaries among the officers. The general had fought in the Mexican war of independence.

Travis quickly realized that the soldiers within the mission's walls could not fend off Santa Anna's large army. He sent out messengers to neighboring cities asking for reinforcements, the nearest being Gonzales, Texas, 70 miles away. Meanwhile, he determined to guard the Alamo until it was taken forcibly by the enemy, swearing "liberty or death." Santa Anna demanded that the Alamo surrender; Travis answered with a cannonball. Before the fighting began, Santa Anna raised a red flag to send a message to the colonists in the post that anybody who was captured would be killed.

The siege of the Alamo lasted for thirteen days. The Mexican army was waiting for cannons strong enough to break through the walls. There were women and children inside the Alamo during the siege. Thirty-two Texan soldiers from Lieutenant George C. Kimbell's Gonzales company finally made it past Mexican lines to come and help the people in the Alamo, but it wasn't enough.

On March 2, Texas declared its independence from Mexico. However, the situation in the Alamo was dire; the walls were crumbling from constant bombardment by the Mexican artillery, provisions were running short, and no reinforcements seemed forthcoming, despite Travis's

pleas to the acting Texas government and other Texas military and volunteer personnel for aid. Although the surrender of the Texans seemed inevitable, Santa Anna commanded his troops to charge. On March 6, the Mexican army attacked the Alamo. The fighting started at 6:30 a.m. and ended an hour and half later. The Texans managed to repulse the first and second attack, cutting down the Mexican soldiers with canisters as they came into close range. The Mexican army broke through the north wall on the third charge and opened the door. The Texans fought hand-to-hand combat as they retreated to the chapel, where they ultimately perished. A few of the men who had not been killed in the fighting were executed. Twenty women and children and two slaves were released. The flag of the New Orleans Greys was captured by the Mexican army. You can view it at the National Historical Museum in Mexico City.

Santa Anna's army was finally overwhelmed later in the war at the Battle of San Jacinto. The men who defeated them rallied to calls of "Remember the Alamo!"

8. THE BATTLE OF GETTYSBURG
July 1–3, 1863

The Battle of Gettysburg, a major battle of the American Civil War, lasted for only three days in 1863, but it will be remembered forever as the bloodiest fight of the war—and a turning point for the ultimately victorious North.

General Robert E. Lee and his Army of Northern

Virginia were on a quest to invade the North, with 75,000 soldiers. Lee's army was broken up into three groups, led by J. Longstreet, R. S. Ewell, and A. P. Hill. J. E. B. Stuart led the cavalry. After an incredible success in May at Chancellorsville, Virginia, which was called Lee's "perfect battle" because his army won against a force twice its size, Lee and his men marched through the Shenandoah Valley to invade the North for a second time. Their goal was to reach Harrisburg, Pennsylvania, or Philadelphia to convince Northerners to let go of the war.

Abraham Lincoln, the president of the United States, sent Major General Joseph Hooker and the Union army after the Confederates. Just before the Battle of Gettysburg, however, Hooker was replaced by Union major general George G. Meade.

On July 1, at dawn, shots were fired over Marsh Creek when the armies met at Gettysburg, where Lee's troops were assembled. The northwest of Gettysburg is marked by low ridges, which were defended by Union cavalry and infantry. But these corps were soon attacked by two big Confederate groups approaching from the north and northwest, which broke through the Union defense and sent the soldiers back through town to the hills in the south.

By the second day, the bulk of both armies met. The Union side was organized like a fishhook, and the Confederates attacked on the left and right sides. Fighting broke out at a few locations, including Little Round Top, Devil's Den, Peach Orchard, Culp's Hill, and Cemetery Hill. Little Round Top is one of two rocky hills to the south

of Gettysburg, and the battle there has been called the highlight of the Union army's defense on the battle's second day. The battle at Little Round Top ended in a famous bayonet charge; there were significant losses on the battlefield, but the Union army held strong.

July 3 saw action on Culp's Hill. Cavalry charged to the east and south, and 12,500 Confederate soldiers advanced on Cemetery Ridge, which rises about forty feet and is barely two miles long. The Confederate army suffered huge losses at Pickett's Charge, which was a disastrous attempt to strike the Union center.

Lee's army retreated all the way back to Virginia—but after three days of fighting, 50,000 Americans were dead.

President Lincoln went to Gettysburg that November

The Gettysburg Address

FOUR SCORE AND SEVEN YEARS AGO, our fathers brought forth on this continent a new nation: conceived in liberty, and dedicated to the proposition that all men are created equal.

Now we are engaged in a great civil war, testing whether that nation, or any nation so conceived and so dedicated, can long endure. We are met on a great battlefield of that war.

We have come to dedicate a portion of that field as a final resting place for those who here gave their lives that that nation might live. It is altogether fitting and proper that we should do this.

But, in a larger sense, we cannot dedicate—we cannot consecrate—we cannot hallow—this ground. The brave men, living and dead, who struggled here have consecrated it, far above our poor power to add or detract. The world will little note, nor long remember, what we say here, but it can never forget what they did here. It is for us the living, rather, to be here dedicated to the unfinished work which they who fought here have thus far so nobly advanced.

It is rather for us to be here dedicated to the great task remaining before us—that from these honored dead we take increased devotion to that cause for which they gave the last full measure of devotion—that we here highly resolve that these dead shall not have died in vain—that this nation, under God, shall have a new birth of freedom—and that this government of the people, by the people, for the people, shall not perish from the earth.

and made a speech at the dedication ceremony for the Gettysburg National Cemetery. That speech, known as the Gettysburg Address, honored the fallen soldiers and called for equality for American citizens. It is Lincoln's most famous speech, and considered one of the greatest speeches in American history.

Major Dates of the Civil War

Dec. 20, 1860—South Carolina First State to Secede
Feb. 4, 1861—Confederate States of America Created
Feb. 18, 1861—Jefferson Davis Inaugurated as Confederate President
April 12, 1861—Fort Sumpter Battle
May 1861—Richmond, Va., Becomes Confederate Capital
July 21, 1861—First Battle of Bull Run
March 9, 1862—*Monitor* vs. *Merrimack*
April 6, 1862—Battle of Shiloh
April 26, 1862—South Loses New Orleans
Sept. 18, 1862—Battle of Antietam
Oct. 8, 1862—Battle of Perryville
May 1, 1863—Battle of Chancellorsville
July 1, 1863—Battle of Vicksburg
July 1, 1863—Battle of Gettysburg

Sept. 19, 1863—Battle of Chickamauga

March 1864—Grant Becomes Commander of Union
 Army

May 1864—Wilderness Battles

Dec. 12, 1864—Sherman Takes Savannah, Ga.

April 9, 1865—Lee Surrenders to Grant

April 14, 1865—Lincoln Assassinated

(Lesson plan—American Civil War,
 http://teacherlink.ed.usu.edu)

UNDERSTANDING GRAMMAR— PART THREE

———✖———

∽ Transitive and Intransitive Verbs ∽

How often will you need to know the difference? Hardly ever, or not at all, but the odd thing is that those who do know these fiddly bits of grammar take *enormous* satisfaction from that knowledge.

Transitive verbs are verbs that must have an object. For example, "to bury," "to distract," "to deny," and many more. You simply cannot write them without an object—"John denied," "Susan buried." John has to deny *something* and Susan has to bury *something* for it to make sense.

Intransitive verbs are verbs that can be complete without an object: "to arrive," "to digress," "to exist."

Some verbs can be transitive or intransitive, depending on how they are used in a sentence (just to make things harder): "The fire burns" (intransitive). "The fire has burned my finger" (transitive—"my finger" is the object). "He has broken the glass" (transitive). "Glass breaks easily" (intransitive).

Again, though, this is not calculating parabolic orbits—recognizing whether a verb is used transitively or intransitively is a matter of care, common sense, and memory.

⤳ The Tenses ⤳

It will come as no surprise to hear that verbs need forms expressing the past, present, and future. There are important differences between someone saying "They have closed the gate" and "They will close the gate." The three *principal* forms of verbs, therefore, express these differences. They are known as present tense, past tense, and future tense.

The Present Tense
There are five forms for a verb in the present tense:

1. Present Simple—*I write.*
2. Present Emphatic—*I do write.*
3. Present Continuous—*I am writing.*
4. Present Perfect Continuous—*I have been writing.*
5. Present Perfect—*I have written.*

The present emphatic form, "I do write," may look a bit odd. It is mostly used in negative statements ("You don't care, do you?"), in questions ("Do you care?"), and strong, emphatic statements ("I do care!").

Sometimes, the present can be used to talk about the future—"I go to New York next week" or "When he arrives, he will hear the news"—but the meaning is clear from context, as it is here: "Tomorrow, I'm going to the store."

The present perfect "I have written" form may also look out of place at first glance. It is used in sentences like the following: "*When I have written this*, I will come and speak to you." This is clearly an action that is going on in the present, coming from the past.

Similarly, present perfect continuous: "*I have been writing* all my life"—again, an action which is going on in the general present, if not at that exact moment.

The Past Tense

The past tense is usually formed by adding *d* or *ed* to the verb (love, *loved*; alter, *altered*); changing the vowel sound (swim, *swam*; throw, *threw*); or remaining the same as the present tense (put, *put*; cast, *cast*).

When the verb ends in a single consonant after a short vowel with the stress on the last syllable, the final consonant is doubled before the *ed* ending (refer, *referred*; fan, *fanned*).

If the letter *y* ends the word after a consonant, it becomes *i* before the *ed* ending (try, *tried*; cry, *cried*).

You'll probably be able to find exceptions to these rules. English has taken so many words from other languages that no rules apply to all of them. However, these work well on most occasions.

There are four standard forms for the past tense:

1. Simple Past—*I wrote.*
2. Past Continuous—*I was writing.*
3. Past Perfect (Pluperfect)—*I had written.*
4. Past Perfect Continuous—*I had been writing.*

There are also a couple of specific constructions, like "used to," that work in sentences about the past. "*I used to* write about relationships, but now. . . ." Clearly, the writing took place in the past.

Similarly, adding "going to" is a common construction: "I was going to call you, but I forgot." The intention of calling took place in the past.

The Future Tense

First a note on "shall," a peculiar little word. It is often used interchangeably with "will." It survives in commandments as "Thou shalt not kill." Its main use is in expressing a future wish. The fairy godmother says "You *shall* go to the ball!" to Cinderella.

One distinction between "will" and "shall" is that "shall" implies some choice. When I was a boy, I was taught that only God could say "I will go to the store" as only he could be certain. The rest of us should say "I shall go to the store" because we could be hit by a bus and not actually make it there. Admittedly, that example rather misses the point that being killed is a little more important than errors of grammar, but it was memorable at least.

The four forms for future time are:

1. Simple Future—*I will write.*
2. Future Continuous—*I will be writing.*
3. Future Perfect—*I will have written*
4. Future Perfect Continuous—*I will have been writing.*

There is also a construction using "am going to," as in "I am going to kill you," and various other minor constructions using adverbs of time: "I am going home *tomorrow*," or adverbial phrases such as "The bus leaves *in ten minutes*."

. . . and that is about it for tenses.

If you've come this far, we know you'll be disappointed if we stop it there. "What about modal verbs? What about the subjunctive?" you will say to yourself. Prepare to be thrilled at the final two sections. This is the gold standard. Take it slowly.

� Modal Auxiliary Verbs ⟿

Modal auxiliary verbs are irregular auxiliary verbs—the sort of verbs that give English a reputation for complexity. The language has many auxiliary combinations, mostly using "to be" and "to have" in combination with another verb: "I *am going*," "I *have been* watching," and so on.

Modal auxiliary verbs are often used to express the speaker's attitude: "You shouldn't do that," or as a conditional tense: "Don't go any closer. *He could be dangerous*."

You use them all the time, however, so do not be too worried. Here is a list of them:

will, *would*, *shall*, *should*, *may*, *might*, *can*, *could*, *must*, *dare*, *need*, *ought*
won't, *wouldn't*, *shan't*, *shouldn't*, *mayn't*, *mightn't*, *can't*, *couldn't*, *mustn't*, *daren't*, *needn't*, *oughtn't*

Note that the use of "need" as a modal verb, as in "Need we do this?" is not that common, whereas "needn't" is used more often: "He needn't enjoy it, as long as he eats it!"

Modal verbs have no infinitive or "-ing" form—"to should" or "maying" do not exist. There is no *s* form of the third person—"he can" not "he cans." They do not stand on their own and are always used in conjunction with other verbs—"May I go to the movies?"

◡ The Subjunctive ◡

The **indicative** mood is the standard factual style of modern English: "I walked into the park." The **subjunctive** mood tends to appear in more formal English, when we wish to express the importance of something. This leads on from the modal verbs, as it too often expresses a wish, an uncertainty, or a possibility. It is frequently formed using modal auxiliaries: "If only they would come!" This is a complex form, and scholarly works have been written on the subjunctive alone. With the limitations of space, we can merely dip a toe.

Present Subjunctive

In the present subjunctive, all verbs look like the infinitive but without the "to"—"do" not "to do"—and they don't take an extra *s*, even in the third person: "We demand that *he do* the job properly."

The verb "to be" provides the most commonly used examples of the subjunctive form. In the present subjunctive, following the rule in the previous paragraph, "be" is used: "Even if that *be* the official view, I must act." In the simple past subjunctive, we use "were" throughout. Example: "If he *were* sorry, he'd have apologized by now."

Here are some examples of classic subjunctive expressions: "Be that as it may," "If I were a rich man," "Suffice it to say," "Come what may," "God save the Queen," "If I were the only girl in the world."

The subjunctive is also used in sentences beginning "If . . . ," as long as the subject is expressing a wish, an uncertainty, or a possibility: "If I were twenty years younger, I would ask you to dance."

Lady Nancy Astor once said to Winston Churchill, "Winston, if I were your wife, I'd put poison in your coffee." He replied, "Nancy, if I were your husband, I'd drink it."

The subjunctive should *not* be used when the "If . . ." construction is a simple conditional: "*If you are ill*, the doctor will make you better." "If" is used here to indicate that one event is conditional on another. There is no sense of a wish or possibility. "If my doctor treats you, he will cure you" is another example of a simple indicative conditional. The

speaker is expressing a fact conditional on the arrival of the doctor, rather than a speculative possibility.

The subjunctive is also used in certain types of sentence containing "that":

1. They demanded *that he take* every precaution.
2. It is essential *that they be* brought back for punishment.
3. I must recommend *that this law be* struck from the books.

Past Subjunctive

In the past subjunctive, all verbs take the common form of the simple past tense. "Have" becomes "had," "know" becomes "knew," and so on. As mentioned above, "to be" is a little different as it becomes "were" (and not "was"), but all the others are regular. Here are some examples:

1. He wept as if *he were being squeezed.*
2. I wish *you were* here!
3. If only *I had worked* in school.

Note that these can be indistinguishable from the standard past perfect "had worked," as in the table. The "If only . . ." and "I wish . . ." beginnings suggest subjunctive.

The following table is almost the end of the grammar section. It covers the subjunctive in all the major tenses,

using examples from the verb "to work" throughout. The important thing to remember is that it might look complicated, but *there is only one form of subjunctive for each verb tense.* If the example is "I work," then all six persons of the verb use that form.

Don't expect to get it immediately—this is one of the really tricky forms of English. The answer, however, is not to stop teaching it and watch it wither away as generations come through school with little knowledge of their own language. The answer to difficulty is always to get your hands around its throat and hold on until you have reached an understanding. Luckily, this is happening—especially in America. The subjunctive is on its way back.

Tense	Indicative	Subjunctive
Simple present	*He works*	*He work*
Present continuous	*She is working*	*She be working*
Present perfect	*He has worked*	*He have worked*
Present perfect continuous	*It has been working*	*It have been working*
Simple past	*We worked*	*We worked*
		(Continued)

Tense	Indicative	Subjunctive
Past continuous	*I was working*	*I were working*
Past perfect	*They had worked*	*They had worked*
Past perfect continuous	*We had been working*	*We had been working*

In addition, here are eight simple sentences in the subjunctive. It is perhaps more common than you realize. Read each one and see how the subjunctive form of the verb is used.

1. He acts as if *he knew* you.
2. I would rather *you had given* a different answer.
3. If only *we had* a home to go to!
4. I wish *I could run* as fast as my older brother.
5. Would that *you were* my friend.
6. I suggest that *he leave.*
7. Thy kingdom *come,* thy will *be* done.
8. If one green bottle *should* accidentally *fall.* . . .

Now go back to the beginning of Understanding Grammar—Part One and read it all again.

BUILDING A WORKBENCH

———※———

BEFORE WE COULD make a number of the things in our books, it was obvious we needed a workbench. Even the simplest task in a workshop becomes difficult without a solid vise and a flat surface.

We kept this as simple as possible. Pine is easiest to cut, but it also breaks, dents, and crushes, which is why classic workbenches are made out of beech, a very hard wood.

Complete beginners should start with pine, as mistakes are a *lot* cheaper. Planning is crucial—every table is different. Ours fitted the wall of the workshop and is higher than almost any workbench you'll ever see. Both of us are tall and prefer to work at a higher level. Draw the plan and have an idea of how much wood you will need.

The suppliers cut the wood square to save time, and we spent two days cutting mortise and tenon joints before assembling it.

RULE: Measure twice and cut once. Carpentry is 80 percent care and common sense, 20 percent skill, or even artistry. You do not have to be highly skilled to make furniture, as long as you *never* lose your temper, plan carefully, and practice, practice, practice. The reason a professional is better than an amateur is because the professional cuts joints every day.

Mortise and Tenon Joints

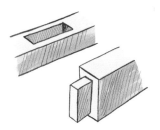

A mortise is a trench cut into wood. The tenon is the piece that fits into the trench.

NOTE: Using sharp tools is not to be undertaken lightly. A chisel will remove a finger as easily as it will remove a piece of wood. Don't try this unless you have an adult willing to show you the basics. There are hundreds of fiddly little things (like how to hold a chisel) that we couldn't fit in here.

We started by making two rectangular frames to go at each end of the table workbench. This is a very simple design, but mortise and tenon joints are strong on the corners.

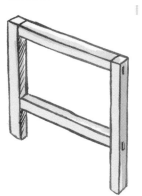

Make sure that the top of your tenon is not too close to the top of the upright. When it comes to cutting the mortise, you do not want to break through.

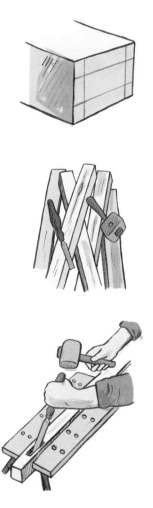

For simple "through" joints, the tenon length is the same as the width of the upright. To create the tenon, you have to make four saw cuts (accurately!) down to a marked line that is equal to the depth of the upright. In the picture, only the middle rectangle will remain. After the four cuts, you saw away the waste pieces and use a chisel to trim any splinters or roughness.

When you have your tenons cut, number them in pencil. Use the tenons as the template for the mortise trenches, also numbered. We also penciled an X on the top side so we wouldn't lose track. Obviously, they should all be identical, but it's odd how often they aren't. Mark the mortises with extreme care, taking note of the exact position. The first upright will be relatively easy, but the

second has to be absolutely identical—and that's where the problems creep in.

Next, cut the mortise. Great care is needed here along with some skill with the chisel. Take care also not to crush the edges as you lever backward. Ideally, you should use a chisel as wide as the mortise itself, although some prefer to use narrower blades.

Once you have your pair of end pieces, you need bars running lengthways to prevent wobble. We used mortise and tenons again, as the beech joints seemed easily strong enough for our needs.

In the picture, you can see that we put both beams on one side. We wanted to have access for storage underneath, so we left the front open.

The rope arrangement in the picture is called a "windlass." It is used when a piece of furniture is too long to be clamped. Most tables will have this problem, and it's good to know you can overcome it with nothing more than a double length of rope and a stick to twist it tighter and tighter. The same technique has even been used to pull wooden ships out of the sea. Be sure to protect the wood with cloth, or you'll cut grooves into your uprights.

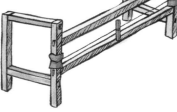

The top planks can be glued together if they have perfect edges, or simply screwed in place. The simplest possible

method is to screw down into the end pieces, but this does leave ugly screw heads visible. We used a corner piece underneath, screwing across into the end piece and also up into the underside of the top. It worked well enough for our purposes.

To finish, we sanded like madmen for the best part of a day, used filler for the gaps we could not explain in the joints, then wiped it all over with linseed oil. The oil soaked in very nicely to seal the wood—just in case we spill paint on it in the future.

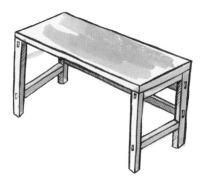

SAMPLING SHAKESPEARE

\Longrightarrow ⚹ \Longleftarrow

N o WRITER OF any age has come close to rivaling the
creative genius of William Shakespeare. He was born
in 1564, on April 23—St. George's Day—in Stratford-
upon-Avon. Anyone alive should have heard about *Mac-
beth*, *Romeo and Juliet*, *A Midsummer Night's Dream*, *King
Lear*, *Othello*, and *Hamlet*, or have seen them in a theater.

Here are a few of the better-known quotations. Shake-
speare has added countless commonly used phrases and
words to English—so common in fact, that we often hardly
recognize them as Shakespearean. He really did write "I
have not slept one wink" before anyone else, as well as "I
will wear my heart upon my sleeve" and hundreds more.

1.

What's in a name? that which we call a rose
by any other word would smell as sweet.

Romeo and Juliet, Act 2, Scene 2

2.

This royal throne of kings, this sceptered isle,
This earth of majesty, this seat of Mars,
This other Eden, demi-paradise,
This fortress built by Nature for herself
Against infection and the hand of war,

This happy breed of men, this little world,
This precious stone set in the silver sea,
Which serves it in the office of a wall,
Or as a moat defensive to a house,
Against the envy of less happier lands,
This blessed plot, this earth, this realm, this England.

Richard II, Act 2, Scene 1

3.

If music be the food of love, play on.

Twelfth Night, Act 1, Scene 1

4.

But screw your courage to the sticking-place,
And we'll not fail.

Macbeth, Act 1, Scene 7

5.

Out, out brief candle!
Life's but a walking shadow, a poor player
That struts and frets his hour upon the stage,
And then is heard no more; it is a tale
Told by an idiot, full of sound and fury,
Signifying nothing.

Macbeth, Act 5, Scene 5

6.

Cry "Havoc!" and let slip the dogs of war.

Julius Caesar, Act 3, Scene 1

7.

Once more unto the breach, dear friends, once more;
Or close the wall up with our English dead!

Henry V, Act 3, Scene 1

8.

Neither a borrower, nor a lender be;
For loan oft loses both itself and friend.

Hamlet, Act 1, Scene 3

9.

All the world's a stage,
And all the men and women merely players.

As You Like It, Act 2, Scene 7

10.

Uneasy lies the head that wears a crown.

Henry IV, Part 2, Act 3, Scene 1

11.

The lady doth protest too much, methinks.

Hamlet, Act 3, Scene 2

12.

To be, or not to be: that is the question:
Whether 'tis nobler in the mind to suffer
The slings and arrows of outrageous fortune,
Or to take arms against a sea of troubles,
And by opposing end them?

Hamlet, Act 3, Scene 1

13.

Let me have men about me that are fat;
Sleek-headed men and such as sleep o' nights.
Yond Cassius has a lean and hungry look;
He thinks too much: such men are dangerous.

Julius Caesar, Act 1, Scene 2

14.

We are such stuff
As dreams are made on, and our little life
Is rounded with a sleep.
[Usually rendered as ". . . dreams are made of"]

The Tempest, Act 4, Scene 1

15.

Why, then the world's mine oyster,
Which I with sword will open.

The Merry Wives of Windsor, Act 2, Scene 2

16.

I am a man
More sinn'd against than sinning.

King Lear, Act 3, Scene 2

17.

There's a divinity that shapes our ends,
Rough-hew them how we will.

Hamlet, Act 5, Scene 2

18.

There are more things in heaven and earth, Horatio,
Than are dreamt of in your philosophy.

Hamlet, Act 1, Scene 5

19.

Something is rotten in the state of Denmark.

Hamlet, Act 1, Scene 4

20.

Double, double toil and trouble;
Fire burn and cauldron bubble.

Macbeth, Act 4, Scene 1

21.

Is this a dagger which I see before me,
The handle toward my hand?

Macbeth, Act 2, Scene 1

22.

Yet do I fear thy nature;
It is too full o' the milk of human kindness.

Macbeth, Act 1, Scene 5

23.

Why, man, he doth bestride the narrow world
Like a Colossus.

Julius Caesar, Act 1 Scene 2

24.

Et tu, Brute!

Julius Caesar, Act 3, Scene 1

25.

This was the most unkindest cut of all.

Julius Caesar, Act 3, Scene 2

26.

Good-night, good-night! parting is such sweet sorrow.

Romeo and Juliet, Act 2, Scene 2

27.

A plague o' both your houses!

Romeo and Juliet, Act 3, Scene 1

28.

Now is the winter of our discontent.

Richard III, Act 1, Scene 1

29.

We few, we happy few, we band of brothers.

Henry V, Act 4, Scene 3

30.

I thought upon one pair of English legs
Did march three Frenchmen.

Henry V, Act 3, Scene 6

EXTRAORDINARY STORIES—
PART THREE

NEIL ARMSTRONG: THE FIRST MAN ON THE MOON

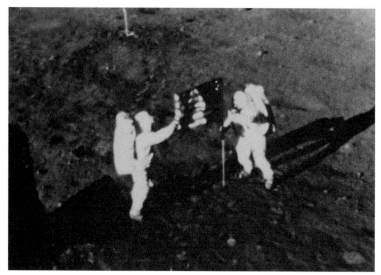

NEIL ARMSTRONG, BORN on August 5, 1930, fell in love with airplanes and flying at an early age. His parents let him take a ride—at the age of six—in a small Ford Tri-Motor plane, nicknamed the "Tin Goose." Neil joined

the Cub Scouts, and by the age of fourteen he had attained the rank of Eagle Scout, He was so fascinated by aircraft that he worked at several after-school jobs around his town and at the local airport in order to pay for flying lessons. On his sixteenth birthday he got his pilot's license, even though he could not yet drive a car!

Neil graduated from high school in Wapakoneta, Ohio, in 1947 and enrolled at Purdue University on a navy scholarship. His early major was aeronautical engineering, but the United States had just entered a war with Korea, and Neil was called to active duty. He was sent to Pensacola (Florida) Naval Air Station where he won his jet pilot wings. The next year he was shipped out to Korea where he flew combat missions in Navy Panther jets. For his expertise and ability Neil received three Air Medals. In 1955 he returned to college and finished his bachelor's degree in aeronautical engineering. He also joined NASA (National Air and Space Administration) as a civilian test pilot and was the project pilot on high-speed planes out of Edwards Air Force Base in California. Having tested and flown the X-15 at more than 4,000 mph, he went on to make seven additional flights, attaining the astounding altitude of more than 200,000 feet. In 1962 he was chosen by NASA to be in their astronaut corps; the following year he became an astronaut and served as command pilot for the Gemini 8 mission. His first flight into space as a bona fide astronaut in 1966 was nearly his last. During the Gemini 8 mission, the spacecraft suddenly wobbled and spun out of control; one of the "thrusters" or directional rockets malfunctioned.

Both Neil and his space partner David Scott used up most of their remaining fuel to stabilize the spacecraft and then had to forgo the remaining orbits for lack of rocket fuel.

In 1968 Neil, along with Edwin "Buzz" Aldrin and Michael Collins, were selected to fly the Apollo 11 mission—the first landing on the moon. On July 16, 1969, the crew blasted off from Cape Canaveral in Florida in the gigantic Saturn V rocket. The Saturn V boosted them into orbit around the moon just four days after takeoff; the lunar module *Eagle*, with Armstrong and Buzz Aldrin inside, separated from the *Columbia* command module, leaving Collins in charge. The *Eagle* was supposed to land on the moon's surface in a relatively flat plain, the Sea of Tranquility. None of the pilots had been able to discern that there were enormous boulders strewn over the surface of the proposed landing stage, so Armstrong manipulated the lunar module to a safer place to make the historic landing. When the *Eagle* finally made contact with the surface of the moon, Armstrong radioed the news to the command module: "The *Eagle* has landed." At 10:56 p.m. EST, Neil Armstrong left the *Eagle*, climbed down the ladder onto the surface, and made history by being the first man to set foot on the moon. His first words, heard around the world, were: "That's one small step for man, one giant leap for mankind." Buzz Aldrin followed his commander; they first set up an American flag, then began collecting surface and rock samples. They also conducted scientific experiments and installed instruments to collect more scientific information. The following day Aldrin and Armstrong

reentered the *Eagle*, fired up the booster rockets, and connected with Collins in the orbiting command module. The *Eagle* was jettisoned into lunar orbit. Four days later, the *Columbia* splashed down near Wake Island in the North Pacific Ocean on July 24, 1969. The command module itself, which held the three astronauts, was relatively small to contain three grown men in space suits. Just 10 feet 7 inches (3.2 m) in height and 12 feet 10 inches (3.9 m) in diameter, the module is on display at the National Air and Space Museum in Washington, D.C. Armstrong was awarded the highest award given to a U.S. citizen, the Presidential Medal of Freedom. He also received the NASA Distinguished Service Medal and the Exceptional Service Medal, the Robert J. Collier Trophy (1969), the Robert H. Goddard Memorial Trophy (1970), and the Congressional Space Medal of Honor (1978).

The year after the moon landing, Neil Armstrong resigned from the astronaut program to return to academia. From 1971 to 1979 he taught at the University of Cincinnati as a professor of aerospace engineering; he then served as chairman of several computing and electronics companies. He was elected to the National Commission on space from 1985 to 1986, and served as cochairman in 1986 on the committee that investigated the explosion of the space shuttle *Challenger*.

WRAPPING A PACKAGE IN
BROWN PAPER AND STRING

<center>⌐─≈✳≈─⌐</center>

Nᴏᴛ ᴀ ᴠᴇʀʏ "dangerous" activity, it's true, but it is extremely satisfying to know how to do this. There are two main ways: one without sticky tape of any kind, and a more ornate one that needs the ends held with tape. We think they both have a place when sending a present or something thoughtful to someone else—just to give them the old-fashioned pleasure of tearing it open. It is true that you could simply cocoon a package in tape, but there is a certain elegance in wrapping it up.

You will need brown paper and string, available from most post offices and all stationery stores.

Place the item to be wrapped on the sheet and cut a piece to fit it. Leave as much as half the height again and three times the width. Be generous rather than stingy with the paper. If it really is too much, you can cut some off later, but you can never put it back on.

If you were using sticky tape, you'd use less paper, fold one sheet under the other, and then tape the edge. Here, we are going to fold the edge down over itself in strips. This will create a "spine" of paper that is very useful for rigidity and finishing it off. It also looks quite good, if you are careful with the folds.

Take a little time getting the ends right. Fold in a middle piece on each side, so that you end up with a duck's

bill in brown paper, as in the picture. This is not the classic "folding triangles in on themselves" technique. It is better.

Fold that duck's bill over itself into a neat point on both ends. You don't need to tape it, just leave it loose. The folded spine will prove very useful to hold it all together while you tie the string.

Now for the string. Cut a nice long piece— three or four feet (90–120 cm). Once again, you can always shorten it. Begin on the side where the final knot or bow will go. Take the string around to the other side and then cross the two pieces as shown, changing directions at ninety degrees. Take the two lines around the other ends

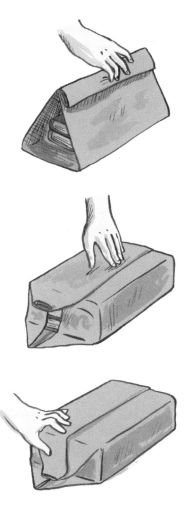

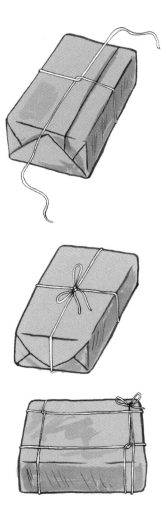

of the package and back to the middle of where you started, for tying. It is helpful to have someone put a finger on the knot to stop it from slipping.

One useful tip is to tie an extra knot before tying the final bow, linking the two lines together on top. This makes it more secure and is a good habit to get into.

The spine of folded paper is underneath. The parcel is neatly wrapped. Well done.

The only drawback to this method is that the crossed strings go right through where you would usually put the address. It is possible to tie the string so that it doesn't, but we found this way needed a bit of tape to hold those ends down.

Instead of starting in

the middle of the parcel, start at one end, running the middle point of a long piece of string underneath. For this method, there is nothing more annoying than running out of string halfway through, so we suggest five feet (150 cm).

Wrap the string around, but this time cross at the three-quarter mark rather than at halfway. Run the strings around the other side and do it again and again, crossing at the corners until you can finally tie it off. As you'll see from the picture, the ends are not held by the string, but this is sturdy—and it leaves a space for the address.

EXTRAORDINARY STORIES— PART FOUR

ARON RALSTON

Aron Ralston, a twenty-seven-year-old mechanical engineer and avid mountain climber from Aspen, Colorado, survived one of the most extreme situations a solo climber can, and he lived to tell the tale. In April 2003, Aron

planned to ride his mountain bike to a site in Canyonlands National Park in southeastern Utah. The area is filled with red rocks, sandstone, sheer cliffs, and narrow canyons—just the sort of thing Ralston enjoyed climbing. He was an experienced solo climber, having scaled most of Colorado's 14,000-foot mountains and the 20,320-foot (6,194 m) Mount McKinley, the highest mountain in North America. On Friday, April 25, Aron packed up his gear and drove his

truck to the trailhead at Horseshoe Canyon. He spent the night in his truck and headed out on Saturday, April 26, on his mountain bike toward Bluejohn Canyon. Once at the Bluejohn trailhead, he parked his bike and secured it to a tree, then started his climb down the canyon walls. His plan was to canyoneer the narrow slots of Bluejohn, then hike out to Horseshoe, where he'd parked his truck, then return to retrieve his mountain bike. In his backpack he carried his mountaineering and rock-climbing gear, a water bottle with about a quart of water, two burritos, a multipurpose knife, a digital camera, a video camera, and a first-aid kit. Dressed in a T-shirt and climbing shorts, he set off into the canyon, rappeling down narrow slots, climbing sheer rock walls like a human fly. When he reached the final push in Bluejohn, a 150-foot rappel, he needed to ascend a large boulder, which was lodged between the narrow canyon walls. As he started his descent on the opposite side of the boulder, it somehow moved several inches and pinned Aron's right forearm against the slot wall. The boulder weighed about 800 pounds, but Aron tried to shift it slightly, just to release his arm from between the boulder and the canyon wall. He used his left arm to maneuver a rope and anchor; it didn't work. Next he tried to chip away at the junction of the boulder and the wall with his multitool, but after nearly ten hours of fruitless chipping, the boulder was still firmly lodged against the slot wall—and his right arm. Now Aron realized that this was more serious than the usual lost-and-injured hiker. He had failed to leave an itinerary; this one time, he thought, it would be okay. One of

the first rules of solo hiking or climbing is to always leave an itinerary, just in case. And he realized now that that primary rule must never, ever be broken.

Night temperatures in the narrow canyon hovered around 30°F; sunlight reached into the slot for only a few hours each day. He ran out of food on the third day in the canyon; he had measured out the remaining water in his liter bottle, but it soon ran out. He knew he had to keep as hydrated as possible, so he caught his own urine in the bottle and sipped that. After being trapped for five days, Aron was able to reach into his backpack and retrieve his video camera. He recorded a "farewell" message to his parents and scratched the date (April 30, 2003), his name, and his birthdate. Due to the pain, dehydration, and exhaustion, Ralston began hallucinating. He thought he could hear voices telling him to make the decision to save himself by cutting off his hand. He now felt sure that unless he were able to sever his arm below the point where it was trapped against the boulder, this would be his last day alive. At this point, Aron's trapped arm had already begun to die from lack of circulation, and he knew that he had to rescue himself or die. He would need to break both arm bones in order to allow him to cut the connective skin and muscles. Could he actually cut off his own arm? Ralston used the leverage between his trapped arm and the boulder, and snapped both the radius and the ulna. Then he made a tourniquet and wrapped it around his upper arm, ensuring that when he severed the arteries he wouldn't lose too much blood. There was little feeling left in the arm, but it was a monu-

mental task just to keep going. He used his multitool to slice the skin away, then used the pliers in the tool to tear the muscles and tendons. The amputation of his right arm right below the elbow took about an hour. Using his small first-aid kit, he applied antibiotic ointment, then gathered up his ropes and anchors so he could rappel the rest of the way down the canyon wall, a distance of more than sixty feet. As he reached the canyon floor, he left his climbing gear and began the long hike back to his truck at Horseshoe Canyon. A family of hikers from the Netherlands was hiking that afternoon near the canyon; they heard Aron's voice calling for help and realized that this must be the lost hiker about whom they had heard from the park ranger.

Back in Aspen, Aron's coworkers had become concerned that he hadn't shown up at work, and they called the park rangers. Aron's mother was notified that he was missing, and she and a friend were able to access Aron's e-mail so they could look for any information or clues to where he might have gone hiking, but even there, no itinerary could be found. Now that the authorities and park rangers were aware of the missing, perhaps injured, solo hiker, more clues began to show up. A credit card receipt from a food store in Moab, Utah, near the Horseshoe Canyon trailhead, alerted rangers that Ralston might be in the area. The sheriff's office found Aron's truck at the trailhead, but there was no sign of the hiker. The search helicopter patrolled the area but again, there was no trace of Ralston. He couldn't be seen from the air because of his position in the

slot canyon. At last, the search helicopter spotted the Dutch family in Horseshoe Canyon, waving and signaling. The copter landed and picked up Aron Ralston, dirty, exhausted, dehydrated, and bleeding . . . from his missing arm. Aron Ralston was just under a mile from the spot where he had parked his truck! The rescue crew quickly made a sling for his injured arm, gave him fresh water to sip, kept him talking so he wouldn't lose consciousness, and took off for the hospital in Moab. Ralston walked into the emergency room unaided and was able to pinpoint exactly where he had gotten trapped in Bluejohn Canyon. Ralston was then transferred to St. Mary's Hospital in Boulder, Colorado, where he underwent surgery to repair what was left of his arm. Now that the authorities in Utah knew exactly where Aron had left his arm, they returned to Bluejohn and found the severed arm. It took an entire crew of thirteen men and heavy equipment to move the boulder enough so the arm could be removed. Aron requested that his arm be cremated; he later returned to the canyon, with prosthesis in place, and left the ashes there. Since his amazing ordeal, Aron wears a special prosthesis with interchangeable attachments— one for mountaineering, another for biking, another for kayaking or rafting, yet another for skiing. He has even helped design special attachments for those who have lost limbs to accidents or disease. He continues to participate in all kinds of extreme sports, and he has given inspiration and hope to the ordinary person who might, one day, be caught in a dire situation and who might need to rely on strength, training, and the ability to make lifesaving decisions.

THE GAME OF CHESS

CHESS IS AN ancient board game that came to Europe along the Silk Road from China and India. It is a game of war and tactical advantage, played by generals and princes down through the ages. Its exact origins are unknown, though the pieces may be based on the ancient formations of Indian armies.

It is a game for two people, played on a board of sixty-four alternately black and white squares. As with most of the best games, it is easy to play badly and hard to play well.

THE PIECES

Both sides have sixteen pieces: eight pawns, two knights, two bishops, two castles (also known as rooks), one queen, and one king.

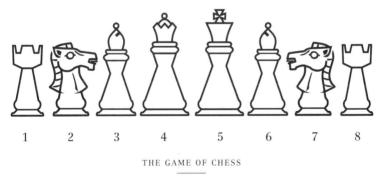

| 1 | 2 | 3 | 4 | 5 | 6 | 7 | 8 |

The object of the game is to capture (checkmate) the opponent's king. White has the first move and then both players take turns until one triumphs.

There should be a white square in the lower right-hand corner when setting up the board. The pieces are arranged in two lines, facing each other. The pawns protect the rear line, which is arranged in the following sequence: 1. Rook; 2. Knight; 3. Bishop; 4. Queen; 5. King; 6. Bishop; 7. Knight; 8 Rook.

The queen always goes on her own color: the black queen on the black square in the middle; the white queen will go on the corresponding white square.

Movement and Values

Each piece moves in a different way.

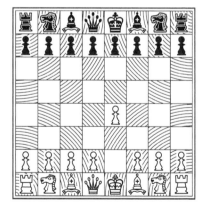

1. **Pawns** are the infantry and move forward, one square at a time—except on the first move, where they are allowed to lurch two squares forward in a fit of martial en-

thusiasm. They capture diagonally, to the left or right. They are the least valuable pieces, but the only ones that can be promoted. (Value: 1 point.)

2. The **Knights** are the cavalry: mobile and difficult to stop. They move in an *L* shape of "two squares and one" in any direction. In the diagram, all the black pawns around the knight can be attacked. Crucially, the knight is the only piece that can jump over others in its path. Even if a rook

Knight

blocked the way to one of the pawns above, the knight could still take the pawn. (Value: 3 points.)

3. **Bishops** are the elephants. They move along the diagonals, though they are limited to white or black squares only. They work well together, covering both color squares. They also do well in distance attacks, like machine guns or searchlights. (Value: 3 points.)

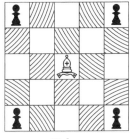

Bishop

4. **Castles** (Rooks). These are the chariot forces. They control the straight lines on the board and are particularly useful in the endgame and for castling. (Value: 5 points.)

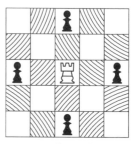

Rook/Castle

5. The **Queen.** This is the most powerful piece on the board and can move in any direction, without limit. (Value: 8 points.)

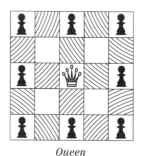

Queen

6. The **King** is the most important piece on the board. It can only move one square at a time, but in any direction. It can move two squares while castling. It cannot move into check. (Value: Game.)

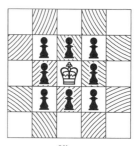

King

The Game

Having the first move is an advantage and most games tend to be won by white. Classically, black plays defensively, countering white's aggressive moves and taking advantage of mistakes.

Capturing. One player removes an enemy piece from the board by landing on the same square. With the exception of a king, any piece can take any other. A king is restricted by the fact that it cannot move into check, so a king can never take another king. Pawns can only capture diagonally, moving forward.

Check/Checkmate. If a piece threatens the king, so that in theory it could take the king, it is called "check." The king *must* either move out of check, block the check, or the attacking piece must be taken. If none of these are possible, the king has been caught—a checkmate, which is a corruption of the Arabic for "The king is dead."

Castling. After the knight and bishop have moved, the king can shift two squares either left or right, with the rook taking the inside square.

En Passant. This is an unusual form of pawn capture that is now common practice. When a pawn has moved down the board, it looks possible to avoid it by moving the

Castling Kingside *Castling Queenside*

opposing pawn two squares up. "En passant" allows pawn capture as if only one square had been moved.

In theory, the game can be split into thirds—the opening, the middle game, and the endgame.

OPENING

The idea here is to get out all your main pieces, known as "developing," before castling your king to safety. The center of the board (the four central squares) is important to control. For example, a knight in the center has up to eight possible moves. In a corner, he may only have two.

Some openings have names and long histories, such as "The King's Indian Defense" and "The Sicilian." There are

many books on openings, but you should find one opening you like and stick to it, playing it often to understand it better. As an example, we'll show you the King's Indian.

Remember, pawns cannot go backward, so move them carefully as you develop. Link them into pawn chains, one protecting the next. Try to avoid leaving a piece "en prise," or undefended.

The Middle Game

Your pieces should be developed and your king safe. This is where you start to attack.

Advance your pieces to positions that help control the board and capture the enemy units. Even at this stage, you should be looking for opportunities to capture the enemy king, but don't overextend your pieces. If you want to move to a square with one piece, make sure it is protected by another.

A "pin" is a piece held in place by the danger of losing a more important piece behind it. Pins work particularly well against the enemy king. Your opponent is unable to move his blocking pieces as he *cannot* move into check.

A "fork" is when a piece threatens two pieces at the same time. The knight is particularly good at this and can be deadly when putting the king in check and at the same time threatening a valuable piece.

A "skewer" is the opposite of a pin, when a valuable piece is forced to move, thereby exposing a lesser piece to capture. A rook that threatens a queen may not get the queen but may take the bishop behind her when she moves.

Remember to keep your king protected in your "castle," stay level on points, and try to get ahead. Even a pawn advantage will show itself in the endgame.

THE ENDGAME

It is possible to win in the middle game, while the board is still full of pieces, but most wins occur in the endgame. The board will be stripped of the main pieces and pawns.

Strangely, the safest position for the king is now the center of the board, where its power can be used to attack and shepherd pawns toward promotion.

Promotion. If a pawn reaches the back rank of the opposing side, it can be exchanged for a queen, rook, bishop, or knight. (You can have two queens! Just turn a rook upside down to represent the second one.) In the endgame, the threat of promotion can have a serious effect on tactics.

The endgame will involve combinations of pieces, as bishops and rooks, for example, attempt to limit the enemy king's movement, check him and then bring about a checkmate. Rooks are particularly strong in the endgame and should not be sacrificed early.

The aim is obviously to checkmate your opponent's king. This is the hardest part of the game and the last thing the novice learns to do *well*.

This is one of the only games where you get to match your brain directly against someone else. It's a level playing field—except for experience, preparation, and intelligence. Do not underestimate preparation. Many a clever boy has been beaten by a better chess player.

Chess is played all over the world, from magnetic sets on trains to ornate bone carved sets in Indonesia. It's a language we all know, and every boy should be able to play chess.

THE SINGLE GREATEST
RACE OF ALL TIME

<div align="center">——————✦——————</div>

THE MILLE MIGLIA, 1955

THE MILLE MIGLIA (thousand mile) road race took place only twenty-four times before being banned. It was a race from Brescia in Italy across the northern plain, down the Adriatic coast, across the mountains to Rome, then to Bologna, and back up to Brescia. Although the route was closed to normal traffic, the cars drove on rough single-lane roads, along hairpin bends, and through the streets of towns with only a few straw bales to protect the crowds. The first race in 1927 was an all-Italian affair and ended in just over twenty-one hours. It quickly became the ultimate road race and the one that all racing drivers wanted to win. Benito Mussolini stopped it briefly in 1938 after a number of spectators were killed, but it resumed in 1940. The final race of 1957 ended with a crash that took the lives of Alfonso de Portago, his navigator, and ten spectators.

On May 1, 1955, the British racing driver Stirling Moss was in position at the starting line. He had Denis "Jenks" Jenkinson with him as navigator, and they had mapped the route on a roll of paper that Jenks unrolled as they went. As well as developing a system of hand signals for Jenks to warn Moss about an upcoming corner, they had

graded them as "saucy ones," "dodgy ones," or "very dangerous ones." Because it was a timed race, Moss knew that he needed every edge he could get if he was to beat Juan Manuel Fangio, twice Formula One world champion and still considered by many to be the greatest driver of all time. In an identical car, Fangio chose to drive alone and would complete the run on roads he knew well.

The cars were numbered according to their starting

time, so that Moss drove #722 and began at 7:22 in the morning. His car, shown on page 230, was a Mercedes-Benz 300SLR, with a 3.0-liter, straight-eight engine, drum brakes, and no seatbelts or safety equipment. It was capable of a top speed of 170 mph.

Exactly ten hours, seven minutes, and forty-eight seconds later, the duo returned. It was a new record for the course. The car was battered and covered in brake dust and dirt. With no protection from the elements, Moss and Jenks themselves were black with grime. In an extraordinary feat of endurance and nerve, they had averaged just under a hundred miles an hour for the entire route, with Moss driving every straight flat out at 170 mph and taking thousands of corners at the absolute limit of the car. They beat Fangio on his home roads by an incredible thirty minutes. Fangio would go on to win the world championship three more times before he retired, but Stirling Moss left him in the dust at the Mille Miglia.

For many years afterward, British police would stop speeding drivers with the words, "Who do you think you are then, Stirling Moss?"

ROLE-PLAYING GAMES

———✦———

THIS IS NOT a chapter telling you *how* to do something— you'll see why as you read. It's a short essay on role-playing games: what they are and how to get started. There are few inventions of the twentieth century that can combine entertainment with imagination so well.

Dungeons and Dragons was put together in 1972. It is still available from online bookshops or game stores. To get started you'll need the player's handbook, the dungeon master's handbook, some dice, and, eventually, an adventure to play. It isn't inexpensive to start, but after the initial outlay, costs are minimal—it's all imagination and the occasional pencil.

In essence, you buy the books, read them, and choose a character for yourself. There are basic classes like Fighter, Thief, and Magic-user. The character will start out with certain qualities such as dexterity and strength, decided by the roll of a die. With experience, the character grows in power, endurance, and knowledge. The game also grows more and more complex. Fighters win more powerful weapons, Wizards gain access to greater spells. When we were children, we progressed from Basic to Advanced to Expert to Immortal levels, before moving on to battling at a national level and building an empire. You never forget the first time you are exiled from a country you raised from nothing.

You do need a few people for this—it is a social game, which is a good thing. In a very real sense, it is a training ground for the imagination and, in particular, a school for plot and character. It may even be a training ground for tactics. If you want to be a writer, try D&D. For that matter, if you want to be a mathematician, try D&D.

The Dungeon Master (or DM) is the one who runs the game. He will either collect or write adventures—literally set in dungeons or just about anywhere. The characters battle the monsters he chooses and either solve his traps or fall prey to them, suffering horrible deaths. The players will develop characters with extraordinarily detailed histories, equipment, and skills.

For us, D&D meant hundreds of hours at school and at home playing with pencils, charts, dice, and laughter. If elves don't grab you, there are many other forms of role-playing—from Judge Dredd, to superheroes, to Warhammer, to a hundred more . . . but Dungeons and Dragons is still the original and the best.

EXTRAORDINARY STORIES—
PART FIVE

<hr/>

MARTIN LUTHER KING JR.

MARTIN LUTHER KING Jr. became a leader and icon of the civil rights movement in the United States. Born on January 15, 1929, in Atlanta, Georgia, King

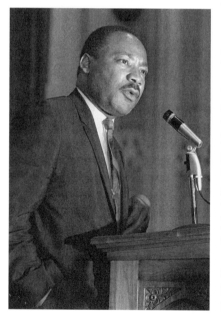

was one of four children of Martin Luther King Sr., the pastor of Atlanta's Ebenezer Baptist Church; King's grandfather was also a Baptist preacher, giving him a full background in Christian ethics and great sensitivity to the injustices suffered by blacks all over the country.

Martin was a top student from the time he entered elementary school in

Atlanta at the age of five; he attended Atlanta University Laboratory School and Booker T. Washington High School, and because of his superior scores on the college entrance exams, he left high school at the age of fifteen and attended Morehouse College, from which he graduated in 1948 with a BA in sociology. Up to that time, King attended segregated schools, which was the law of the land. That year also saw King's ordination to the ministry at Ebenezer Baptist Church, where he became the assistant pastor; in September 1948 he enrolled at the predominantly white Crozer Theological Seminary in Chester, Pennsylvania, and also attended classes at the University of Pennsylvania. At Crozer, he was unanimously elected president of the senior class and thus delivered the graduation valedictory address, having also won several awards for most outstanding student (the Pearl Plafker Award) and the Crozer fellowship for graduate study. In 1951 King received his Bachelor of Divinity (BD) from Crozer; later that year he entered Boston University to begin his doctoral studies in systematic theology and also studied at Harvard University. He received his PhD from Boston University in 1955.

In 1954 Martin answered the call to the pastorate of the Dexter Avenue Baptist Church in Montgomery, Alabama. He had always been a strong advocate for equal rights for people of all races, but especially for blacks, who had for more than a century been denied their basic civil rights in the South. While in Montgomery he joined the National Association for the Advancement of Colored

People and was an active member of the executive committee. More and more King believed that nonviolent resistance was the best option for all oppressed people, and in 1955 he led the first nonviolent demonstration in modern times in the United States—the famous bus boycott. Negroes had not been allowed to sit anyplace but in the rear seats of public transportation, and King's boycott, where blacks preferred to walk rather than ride, lasted for 382 days. King and his followers and supporters were arrested and found guilty of conspiracy, but they appealed and were released. King's reputation grew and he was beginning to emerge as a national hero. In a historic decision on December 15, 1956, the Supreme Court of the United States declared that the law requiring segregation on public transportation was unconstitutional: blacks and whites could now ride buses as equals. Following the success of the bus boycott, King was elected president of the Southern Christian Leadership Conference, which had been formed to give support and create new leadership for the civil rights movement. With King at the helm, the movement's tenets spread throughout the country; the overall goal was to end segregation in all segments of public life. King held the organization together with a combination of Christian ideals and the nonviolent techniques he learned from studying Gandhi. During the eleven years King headed the SCLC (1957–1968), he felt called to go wherever there was a need to speak out against injustice and prejudice. He traveled throughout the country, gave more than 2,500 speeches, and wrote

six books and hundreds of articles, outlining his commit-ment to justice and freedom. Wherever there were pro-tests against segregation, against blacks being allowed to vote, wherever there was discrimination of any kind, Martin Luther King Jr. was there, speaking eloquently of action, love, and peace. He was arrested more than twenty times during this period; in jail in Birmingham, Alabama, he wrote the now famous "Letter from Bir-mingham Jail," which called for what he said would be "a coalition of conscience." The year 1963 also saw King's peaceful "March on Washington," to which more than 250,000 people attended. It was here that King delivered his "I Have a Dream" speech, and met with President John F. Kennedy. He was awarded many honorary de-grees, named *Time* magazine's Man of the Year, and in 1964, at the age of thirty-five, Martin Luther King Jr. was awarded the Nobel Peace Prize. He gave the prize money ($54,123) to the civil rights movement. Now a world-famous figure and in great demand by groups from all walks of life from all races, King became more and more outspo-ken on the prejudicial and unjust actions of those in power. On April 4, 1968, Dr. King was assassinated while standing on the balcony of the Lorraine Motel in Mem-phis, Tennessee. He had gone there to lead a protest march in support of the sanitation workers, whose work-ing conditions and low wages had become intolerable. Now looked on as a martyr, King's legacy has inspired thousands of leaders throughout the world to seek peaceful change. His leadership, lectures, speeches, and

marches did indeed bring significant changes to the lives of black Americans in a time when social unrest, injustice, and hate conspired to tear apart the fabric of the country. He gave to hundreds of thousands of poor and black people a new sense of dignity and hope for their futures and the futures of their children.

Coretta Scott King, Martin's widow, established the King Center in 1968. It is located in Atlanta, Georgia, in the Martin Luther King Jr. National Historic Site. The center draws more than a half million visitors and scholars from every country; his books, papers, speeches, and various communications media are available for all who want to learn more about "the American saint" so they can continue to spread his philosophy of nonviolence and create social change and peace throughout the world.

I Have a Dream

(Delivered on the steps at the Lincoln Memorial in Washington, D.C., on August 28, 1963)

Five score years ago, a great American, in whose symbolic shadow we stand signed the Emancipation Proclamation. This momentous decree came as a great beacon light of hope to millions of Negro slaves who had been seared in the flames of withering injustice. It came as a joyous daybreak to end the long night of captivity.

But one hundred years later, we must face the tragic fact that the Negro is still not free. One hundred years

later, the life of the Negro is still sadly crippled by the manacles of segregation and the chains of discrimination. One hundred years later, the Negro lives on a lonely island of poverty in the midst of a vast ocean of material prosperity. One hundred years later, the Negro is still languishing in the corners of American society and finds himself an exile in his own land. So we have come here today to dramatize an appalling condition.

In a sense we have come to our nation's capital to cash a check. When the architects of our republic wrote the magnificent words of the Constitution and the Declaration of Independence, they were signing a promissory note to which every American was to fall heir. This note was a promise that all men would be guaranteed the inalienable rights of life, liberty, and the pursuit of happiness.

It is obvious today that America has defaulted on this promissory note insofar as her citizens of color are concerned. Instead of honoring this sacred obligation, America has given the Negro people a bad check which has come back marked "insufficient funds." But we refuse to believe that the bank of justice is bankrupt. We refuse to believe that there are insufficient funds in the great vaults of opportunity of this nation. So we have come to cash this check—a check that will give us upon demand the riches of freedom and the security of justice. We have also come to this hallowed spot to remind America of the fierce urgency of now. This is no time to engage in the luxury of cooling off or to take the tranquilizing drug of gradualism. Now is the time to rise from the dark and

desolate valley of segregation to the sunlit path of racial justice. Now is the time to open the doors of opportunity to all of God's children. Now is the time to lift our nation from the quicksands of racial injustice to the solid rock of brotherhood.

It would be fatal for the nation to overlook the urgency of the moment and to underestimate the determination of the Negro. This sweltering summer of the Negro's legitimate discontent will not pass until there is an invigorating autumn of freedom and equality. Nineteen sixty-three is not an end, but a beginning. Those who hope that the Negro needed to blow off steam and will now be content will have a rude awakening if the nation returns to business as usual. There will be neither rest nor tranquility in America until the Negro is granted his citizenship rights. The whirlwinds of revolt will continue to shake the foundations of our nation until the bright day of justice emerges.

But there is something that I must say to my people who stand on the warm threshold which leads into the palace of justice. In the process of gaining our rightful place we must not be guilty of wrongful deeds. Let us not seek to satisfy our thirst for freedom by drinking from the cup of bitterness and hatred.

We must forever conduct our struggle on the high plane of dignity and discipline. We must not allow our creative protest to degenerate into physical violence. Again and again we must rise to the majestic heights of meeting physical force with soul force. The marvelous new mili-

tancy which has engulfed the Negro community must not lead us to distrust of all white people, for many of our white brothers, as evidenced by their presence here today, have come to realize that their destiny is tied up with our destiny and their freedom is inextricably bound to our freedom. We cannot walk alone.

And as we walk, we must make the pledge that we shall march ahead. We cannot turn back. There are those who are asking the devotees of civil rights, "When will you be satisfied?" We can never be satisfied as long as our bodies, heavy with the fatigue of travel, cannot gain lodging in the motels of the highways and the hotels of the cities. We cannot be satisfied as long as the Negro's basic mobility is from a smaller ghetto to a larger one. We can never be satisfied as long as a Negro in Mississippi cannot vote and a Negro in New York believes he has nothing for which to vote. No, no, we are not satisfied, and we will not be satisfied until justice rolls down like waters and righteousness like a mighty stream.

I am not unmindful that some of you have come here out of great trials and tribulations. Some of you have come fresh from narrow cells. Some of you have come from areas where your quest for freedom left you battered by the storms of persecution and staggered by the winds of police brutality. You have been the veterans of creative suffering. Continue to work with the faith that unearned suffering is redemptive.

Go back to Mississippi, go back to Alabama, go back to Georgia, go back to Louisiana, go back to the slums and

ghettos of our northern cities, knowing that somehow this situation can and will be changed. Let us not wallow in the valley of despair.

I say to you today, my friends, that in spite of the difficulties and frustrations of the moment, I still have a dream. It is a dream deeply rooted in the American dream.

I have a dream that one day this nation will rise up and live out the true meaning of its creed: "We hold these truths to be self-evident: that all men are created equal."

I have a dream that one day on the red hills of Georgia the sons of former slaves and the sons of former slave-owners will be able to sit down together at a table of brotherhood.

I have a dream that one day even the state of Mississippi, a desert state, sweltering with the heat of injustice and oppression, will be transformed into an oasis of freedom and justice.

I have a dream that my four children will one day live in a nation where they will not be judged by the color of their skin but by the content of their character.

I have a dream today.

I have a dream that one day the state of Alabama, whose governor's lips are presently dripping with the words of interposition and nullification, will be transformed into a situation where little black boys and black girls will be able to join hands with little white boys and white girls and walk together as sisters and brothers.

I have a dream today.

I have a dream that one day every valley shall be ex-

alted, every hill and mountain shall be made low, the rough places will be made plain, and the crooked places will be made straight, and the glory of the Lord shall be revealed, and all flesh shall see it together.

This is our hope. This is the faith with which I return to the South. With this faith we will be able to hew out of the mountain of despair a stone of hope. With this faith we will be able to transform the jangling discords of our nation into a beautiful symphony of brotherhood. With this faith we will be able to work together, to pray together, to struggle together, to go to jail together, to stand up for freedom together, knowing that we will be free one day.

This will be the day when all of God's children will be able to sing with a new meaning, "My country, 'tis of thee, sweet land of liberty, of thee I sing. Land where my fathers died, land of the pilgrim's pride, from every mountainside, let freedom ring."

And if America is to be a great nation this must become true. So let freedom ring from the prodigious hilltops of New Hampshire. Let freedom ring from the mighty mountains of New York. Let freedom ring from the heightening Alleghenies of Pennsylvania!

Let freedom ring from the snowcapped Rockies of Colorado!

Let freedom ring from the curvaceous peaks of California!

But not only that; let freedom ring from Stone Mountain of Georgia!

Let freedom ring from Lookout Mountain of Tennessee!

Let freedom ring from every hill and every molehill of Mississippi. From every mountainside, let freedom ring.

When we let freedom ring, when we let it ring from every village and every hamlet, from every state and every city, we will be able to speed up that day when all of God's children, black men and white men, Jews and Gentiles, Protestants and Catholics, will be able to join hands and sing in the words of the old Negro spiritual, "Free at last! free at last! thank God Almighty, we are free at last!"

Source: Martin Luther King Jr. *The Peaceful Warrior.* New York: Pocket Books, 1968.

BOOKS EVERY BOY SHOULD READ

THE DANGER HERE is that you'll try to read books that are too hard for your age. The choices are from those books we enjoyed, but this is a list that all *men* should have read when they were boys. The first ones are the easiest—though not the best. Every title has been loved by millions. Like a reference to Jack and the Beanstalk, you should know Huckleberry Finn, Sherlock Holmes, and all the other characters who make up the world of imagination. The list comes with suggested reading ages—but these are only rough minimums. Reading ability is more important than age.

1. Roald Dahl's books. From 5 up, these can be read to children. *The Twits* is fantastic. *Charlie and the Chocolate Factory*, *George's Marvellous Medicine*, *The BFG*, and *James and the Giant Peach* are all worth reading. For older readers, his short stories are nothing short of brilliant.

2. *The Phantom Tollbooth* by Norton Juster. Classic fantasy/adventure with lots of puns. Readers from age 8 and up.

3. *Robinson Crusoe* by Daniel Defoe. High seas, desert islands, adventure, it's all here. Ten and up.

4. All the Famous Five books by Enid Blyton. Also, her Secret Seven series. These are classic adventure and crime stories for those age 8 and above, up to the early teens.

5. The Melendy Quartet (*The Saturdays, Four-Story Mistake, Then There Were Five, Spiderweb for Two*) by Elizabeth Enright. Well-written short novels about a close-knit family and their adventures. Ages 8–12.

6. *Grimm's Fairy Tales*; Hans Christian Andersen; Greek and Roman legends. There are many collections out there, but these stories have survived because they are good.

7. Swallows and Amazons series by Arthur Ransome. These books are perfect for summer afternoon reading up in the tree house. Read all of them. Ages 9–12.

8. His Dark Materials trilogy by Philip Pullman. Excellent adventure/fantasy trilogy, beautifully written by a master of suspense. All ages.

9. *The Lion, the Witch and the Wardrobe* by C. S. Lewis. The second of the Narnia series. Superb fantasy stories for confident readers 12 and above.

10. *Charlotte's Web* and *Stuart Little* by E. B. White. Both powerful and beautifully written stories. Eight years old and up.

11. *Kim* by Rudyard Kipling—a classic adventure. Also, the *Just So Stories* and *The Jungle Book*. For confident readers but well worth the time.

12. *The Thirty-Nine Steps* by John Buchan. This is almost the definition of a boy's adventure story, involving spies and wild dashes across the Scottish countryside. Also look for *Mr. Standfast* by the same author.

13. The James Bond books by Ian Fleming. For early teen readers and above. These stories are quite dark in places—far grittier than the films.

14. The Harry Potter books by J. K. Rowling. Modern classics.

15. *The Outsiders*, *Rumble Fish* by S. E. Hinton. Misadventure of growing up in the Midwest. Ages 12 and up.

16. Mark Twain—*The Adventures of Tom Sawyer* and *The Adventures of Huckleberry Finn*. For confident readers of 12 and above.

17. Isaac Asimov—science fiction. He wrote hundreds of brilliant short stories, available in collections. Confident readers of 12 and above.

18. Terry Pratchett's Discworld books. They are all fantastic, funny, and interesting. Start with *Sourcery*. Twelve and above.

19. *Riders of the Purple Sage* (and others) by Zane Grey. Idealized versions of the Old West but good reading. All ages.

20. *Journey to the Center of the Earth*, *Twenty Thousand Leagues under the Sea* by Jules Verne. This author wrote about submarines, science fiction, and space travel long before they became realities. Confident readers 12 and up.

21. *The Hitchhiker's Guide to the Galaxy* by Douglas Adams. Funny and clever—the old "five books to a trilogy" ploy. Twelve and up.

22. *The Black Pearl, Island of the Blue Dolphins* by Scott O'Dell. O'Dell's books are kindly written and full of adventure and intrigue. Ages 10 and up.

23. *Call It Courage* by Armstrong Sperry. A sensitive telling of a Polynesian tale of a young boy's quest for independence and recognition. Ages 12 and up.

24. *The Lord of the Rings* by J. R. R. Tolkien. The master-work trilogy. For confident teen readers.

25. *Call of the Wild* by Jack London. Classic tale of the adventures of a sheepdog in the Arctic. All ages.

26. The Flashman books by George MacDonald Fraser. For confident readers, but a great dip into history and adventure. Fourteen and above.

27. *Animal Farm* and *1984* by George Orwell. Novels to wake up the brain. For confident readers of 14 and over.

28. *Brave New World* by Aldous Huxley. Like Orwell's *1984*, a famous story of a future we should fear.

29. *Lord of the Flies* by William Golding. Superb—but only for accomplished readers of 14 and above.

30. H. G. Wells's *The Time Machine*, *The Island of Dr. Moreau*, *The Invisible Man*—books from one of the best literary minds of the twentieth century. Fourteen and above.

31. The Sherlock Holmes adventures by Arthur Conan Doyle. The original classic detective mysteries. Loads of short crime stories and longer novels, like *The Hound of the Baskervilles*. Accomplished readers only. Fifteen and above.

32. *Gulliver's Travels* by Jonathan Swift. One that can be read on more than one level. It gave us the lands of Lilliput and Brobdingnag.

33. *To Kill a Mockingbird* by Harper Lee. A classic, short novel; memorable characters, and required reading for all ages.

34. Stephen King. *The Bachman Books* is a good starting point. His novels are quite adult in subject and can be very frightening. Accomplished readers only—15 and above.

ILLUSTRATIONS

—✦—

Illustrations on pp. 30, 32, 140–142, 149–151, 159–162, 165–169, 195–198, 211–212, 233, 245 © Joy Gosney 2008

DANGEROUS THINGS I HAVE LEARNED

——⟶✳⟵——

The Pocket

DANGEROUS

Book
for

Boys

THINGS TO DO

Conn Iggulden & Hal Iggulden

THE POCKET DANGEROUS BOOK
FOR BOYS: THINGS TO DO

The Dangerous Book for Boys inspired a newfound passion for adventure, fun, and all things "dangerous." Now that you have read *The Pocket Dangerous Book for Boys: Things to Know*, have you tried its companion book, the No. 1 bestseller *The Pocket Dangerous Book for Boys: Things to Do*?

With everything from how to win at poker, how to make a paper hat and how to skip stones to how to tie a knot and how to write a note in secret ink, *The Pocket Dangerous Book for Boys: Things to Do* is packed with fun things to do for every boy.

ISBN: 978-0-06-165682-8

THE DANGEROUS BOOK FOR BOYS

The bestselling original book for every boy from eight to eighty

How many other books will help you defeat someone at poker, race your own go-cart, and identify the best quotations from Shakespeare? *The Dangerous Book for Boys* gives you facts and figures at your fingertips—brush up on the solar system, learn about famous battles, and read inspiring stories of incredible courage and bravery. Teach your old dog new tricks. Make a pinhole camera. Understand the rules of soccer. There's a whole world out there: with this book, anyone can get out and explore it.

"A delightful collection of old-fashioned mischief."
—*New York Post*

ISBN 978-0-06-124358-5

On Sale Now